GETTING HERE FROM THERE

Getting Here from There

CONVERSATIONS ON LIFE AND WORK

by
Margaret R. Miles
and Hiroko Sakomura

CASCADE *Books* · Eugene, Oregon

GETTING HERE FROM THERE
Conversations on Life and Work

Copyright © 2011 Margaret R. Miles and Hiroko Sakomura. All rights reserved. Except for brief quotations in critical publications or reviews, no part of this book may be reproduced in any manner without prior written permission from the publisher. Write: Permissions, Wipf and Stock Publishers, 199 W. 8th Ave., Suite 3, Eugene, OR 97401.

Cascade Books
An Imprint of Wipf and Stock Publishers
199 W. 8th Ave., Suite 3
Eugene, OR 97401

www.wipfandstock.com

ISBN 13: 978-1-61097-053-2

Cataloging-in-Publication data:

Miles, Margaret R. (Margaret Ruth), 1937–

Getting here from there : conversations on life and work / Margaret R. Miles and Hiroko Sakomura.

xiv + 128 p. ; 23 cm. — Includes bibliographical references.

ISBN 13: 978-1-61097-053-2

1. Feminism and higher education — United States. 2. Feminism and art — Japan. I. Sakomura, Hiroko. II. Title.

LC1567 M55 2011

Manufactured in the U.S.A.

*For our daughters and granddaughters
Susan and Tomoko, Minori and Siduri*

Contents

Acknowledgments ix

Introduction xi

PART I: FROM THERE

1 Growing Up 3
2 Socialization 16
3 Relationships 25
4 Children 33

PART II: STRATEGIES

5 Images and Models 49
6 Habits 57
7 Critique and Self-Criticism 64
8 Style 75
9 Energy and Power 81
10 Pleasure and Happiness 85

PART III: TO HERE

11 Professional Life 93
12 Religion 107
13 Society and Public Life 114
14 Aging 120

Epilogue 125

Sources for Quotations 127

Acknowledgments

THE PLEASURE OF OUR conversations made the work of the book insignificant. We first thank each other for the openness with which we were willing to reveal both joys and sorrows. The book would not have been possible without Hiroko's fluency in English, which permitted a detailed and nuanced account of her experience that Margaret was completely incapable of in Japanese! Moreover, Hiroko arranged the opportunities for us to talk in person, originally in the North American exhibition venues for "The Vision and Art of Shinjo Ito"—New York, Chicago, and Los Angeles. After the exhibition moved on to Europe, and then back to Japan, Margaret came to Tokyo to give the lecture at the headquarters of the Shinnyo-en Buddhist Order. Hiroko then took her to the beautiful mountain town where she was born. For several days there we balanced further conversations with enjoyment of the beauty of surrounding landscapes—in cherry and plum blossom time, no less! Finally, Hiroko came to Berkeley twice to give us time to continue our work together. Margaret transcribed and edited the tapes of our conversations.

About now, in writing acknowledgements, one is overwhelmed by memories and images of the many people who helped. Michiaki Okuyama, Mark Robinson, Tara Hohenberger, Yoshiko Kanai, Mikiko Shirakura, and many others whose support we appreciate—family members and friends. We especially thank Melanie and Terry O'Hare for their hospitality while we worked in Berkeley. Many thanks to our editor at Wipf and Stock Publishers, Charlie Collier.

In the wings are the mothers and grandmothers who nurtured and taught us, who, by their example, showed us what kind of lives we wanted

Acknowledgments

and did not want. We have tried to balance our unwillingness to relive their lives with the gratitude and love we feel for them. We hope we got it right!

Introduction

FORMER PRESIDENT OF HARVARD University Derek Bok was both amused and impressed to learn that Margaret, a tenured Harvard faculty member and holder of a funded chair, began her academic career teaching in California community colleges. "You can't get here from there," he joked. But she did.

Margaret married at the age of eighteen; by the time she was twenty-two she had two children and an ulcer that threatened to perforate. The wife of a Presbyterian minister, she had tried to be content with children, church, and television. The ulcer made it painfully clear that this was not working. It prompted her to begin seven years of psychotherapy in which the energy that had been chewing her stomach lining went to her head and she became a voracious reader. At the age of twenty-six, she began taking classes at the nearest community college, always getting home before her children arrived from school. Sneaking studying, she tried to show that she was not doing anything but being a good wife and mother. She continued schooling, term by term, always attending the nearest school, not with the goal of completing a degree program, but because she was avid to learn more. One thing led to another, as her mother—in a different context—always said it would. At the age of forty-one she began a career with a doctorate and an assistant professor position at Harvard University's Divinity School.

Hiroko, a young girl from a small Japanese town, became the owner of her own company and a much sought-after producer of exhibitions and cultural events in Europe, North and South America, and Asia. Hiroko was born in Yamaguchi which is surrounded by mountains—the name means "gate to the mountains." Francis Xavier brought Catholicism to the region in the sixteenth century, and the cathedral, with its towers

Introduction

and ringing bells, constantly reminded Hiroko of the world beyond Yamaguchi. Her aunt, who became a Catholic, sometimes took her to services. Inside the church, the artworks and stained glass reinforced her awareness of a very different world than the one to which she was accustomed. Hiroko was precocious and curious, always longing to see what was beyond the mountains.

Margaret and Hiroko met when Hiroko was producing an international exhibition of Buddhist art. The exhibition, "The Vision and Art of Shinjo Ito," consisted of sculpture, calligraphy, and photography created by the founder of the Shinnyo-en Buddhist Order. It traveled to five cities in Japan, where more than 310,000 visitors saw the exhibition. It then traveled to three American cities—New York, Chicago, and Los Angeles. In each of the American venues, Margaret gave a lecture on the use of vision in religious practice. The exhibition then opened in Florence and Milan. In these venues, seventy thousand people saw the exhibit. At every opportunity we—Hiroko and Margaret—talked together, fascinated by our similarities and differences. When we realized that our conversations might be interesting to others, we began to tape them. When we wrote this book we decided to retain the lively conversations that initially attracted and fascinated us, rather than reworking them as narratives or essays.

One of our first discoveries was that both of us had grown up with conventional ideas of what our lives would be: we would get married and have children; we would need to think no further about what we might do. Both of us have found it necessary radically to rethink those assumptions.

Our differences make for interesting comparisons. We grew up in different societies; we have different educations, different professions, and different religious orientations. Our societies have inhibited and enabled us in different ways. This book explores our journeys from "there" to "here." In it we reflect on our careers and our personal lives, our hard work, our lucky opportunities and our painful losses. We can only suggest some working answers to the questions we raise, for we do not speak for all Japanese and American women, but simply as Hiroko and Margaret. Certainly, we hope to encourage other women to find and create opportunities to exercise their talents and training, but we claim only that the ideas and methods we discuss *worked for us*.

Introduction

Early in our conversations about writing a book Hiroko asked, "What shelf will our book be on in the bookstore? It's not a self-help manual, and it's not about religion or philosophy; it's not autobiography." "It's memoirs," Margaret suggested, "but memoirs that stretch the boundaries of the genre." In addition to the memories and reflections of each of us, it compares our experiences of living in different societies in the twentieth and twenty-first centuries. The topics we discussed are grouped in roughly chronological order; they need not be read in order, however, but as the reader's interest directs.

In the past, cautionary tales have effectively prevented most women from transgressing established gender roles and expectations. From *Antigone* to *Thelma and Louise*, women who broke the rules in order to seek pleasure or achievement were punished—in life as in literature—by madness or death. In Western Europe, between about 1500 and 1700, despite disagreement among historians about witch persecution figures, it is clear that "women were disproportionately targeted. In some locations, seventy-five to eighty percent of those accused of witchcraft were women, and up to ninety percent of those executed as witches were women."[1] Witches were accused of possessing a long list of vindictive powers; they were believed to cause everything from impotence, to miscarriage, to death. Even in historical societies with revered women leaders, however, the lives of most women were constricted. In Japan, for example, despite social recognition of a famous third-century shaman queen, Himiko, and even a few women emperors, chauvinistic attitudes are common.

We live in an amazing historical moment in Japanese and American societies, a moment characterized by the development of one of the most radical social movements in the history of the world. Our societies are being reshaped as women come closer than ever before to equality with men, gaining access to designing and administering the institutions of public life with its opportunities, dangers, and rewards. The present is most easily understood by contrasting it with an earlier time. In mid-twentieth century America, feminist leaders sought to identify and reject feminine gender socialization and to overturn gender roles and expectations. This was a necessary historical moment; it got public attention. Feminists were frequently accused of being "shrill and strident." As Catherine MacKinnon once said, "I'm a feminist—not the fun kind."

1. Miles, *A Complex Delight*, 18.

Introduction

However, as women of diverse races and ethnicities quickly pointed out, at this stage feminism articulated the perspectives of white middle-class women. Presently, after several decades of criticism and revision, the movement no longer belongs to its originators; it has become exponentially more populous, complex, and global. Its goals are also different. Feminists no longer seek to overturn societies so that women, formerly on the bottom, are now on top. Many feminists—or those who would like to call themselves feminists if the word were not so over-determined by negative stereotypes—seek the right of women *and men* to transgress gender roles and expectations in the direction of identifying and actualizing their individual capacities, skills, and pleasures.

In both Japanese and American societies many women "want it all now," in the best sense of that phrase. That is, we want to preserve and reinterpret certain traditional values while exercising our capabilities and skills both in public and in the home. Which traditional values and roles do we want to maintain? And how do they need to be reinterpreted? For example, it is important to us to find ways of caring for others that are compatible with our professional commitments and that do not lead to burnout. Our socialization has proven inadequate on this point. Both of us were taught to ask, what is the *right* thing to do, not what can *I* do in this situation? The latter question requires thoughtful assessment of what my specific capabilities and energy permit in this particular situation. Second, although we were taught by word and example that we should make ourselves agreeable and pleasing to everyone, we found that trying to please does not necessarily produce good relationships. Examples of our adjustments of these expectations appear throughout the book. Moreover, both of us have needed to rework such large issues as our philosophy of life, our religious ideas and practices, and our attitudes toward sex, rejecting some aspects of the values with which we grew up, and maintaining and refining others.

From unlikely origins, Hiroko and Margaret created fulfilling and productive lives. A generation earlier it probably would not have been possible. And we hope that a generation later it will not be interesting because everyone will be doing it! In this book we examine *how it worked for us*, in order to stimulate and encourage other young women from similar origins to get "here" from there.

Part I

FROM THERE

1

Growing Up

> "So much depends on how we understand what happened to us.... So much depends on how we tell ourselves the story of our lives, in dreams and day-dreams."
> ~ James R. Garner

HS: As the first daughter in my family of origin, I was taught to dress properly, to speak politely, and to please my parents in every way. I wasn't either encouraged or discouraged toward a career. My duty as the eldest daughter was to be helpful and nice to everybody and to look after my younger brother and sister. It was a matter of pride to me that my behavior was right. My parents didn't even need to express their expectations; I knew what they were and I performed perfectly.

I tried hard to please not only my parents, but everyone. I wasn't an unhappy or frustrated child; there is a certain pleasure in achieving and pleasing others, but I also knew that I wanted to get away. I had a brother who was two years younger, and a sister who was four years younger than I. I was taught that I had to protect them, not just at home but at school and even when we were outside, playing with friends. I always made sure they were safe and comfortable. The habit of caring for others was deeply rooted. Later, if I was traveling with somebody on a bus or train, I always tried to think of a topic I could offer for conversation. It exhausted me. It

took me a long time to learn that I didn't have to take care of everyone. There's a Japanese saying *happou bijin*—trying to be a beautiful woman in eight different directions. This behavior reveals neediness and the search for reassurance.

In Japan, from the day you enter elementary school to the day you begin junior high at age twelve, you usually have the same teacher for almost every subject and activity. Students are not given the benefit of having different teachers with different styles and perspectives. If you get along with your teacher you'll be fine, but you'll be in trouble if you don't. I had the same teacher throughout elementary school, and I was a model student, the teacher's pet. I got the best grades all the time. I was class vice captain, an athletics star, a soprano in the chorus group, and the library monitor.

My brother, sister, and I went to the same school. Although Yamaguchi is the capital of the prefecture, I felt stifled because of the attractive images I had of the outside world. When I was ten all my favorite television programs were from the United States: *Father Knows Best*, *The Patty Duke Show*, Disney, *Ben Casey* and so on. I thought that television shows were based on real life in America, and that America was a dreamland. Charming girls always met handsome boys, had very understanding parents, and their friends and neighbors were kind and helpful. Houses were neat and tidy, full of convenient electric appliances in the kitchen, and there were many flavors of ice cream and cookies. People dressed fashionably. Their weekends were occupied with dating and parties. Their dinner table conversations were filled with laughter and great stories. I thought that American husbands and wives were constantly attentive to each other, saying "I love you" as often as possible. It was just beautiful! I thought that if I could get to America I too could have that kind of marriage.

Of course my reality at home was different. Marriage for love was unusual at the time, and my parents' life was not like the marriages I saw on television. My mother helped my father with his accounting, but even though she made a great contribution to the company, when the business expanded my father suddenly asked her to quit, because he wanted the company to be seen as more than a family business. She was hurt, and I realized that I didn't have any usable female role models. All the women I knew were controlled by men. Although I've never thought

my mother's or my grandma's lives were sad and miserable, I knew that I didn't want to live as they did.

My grandmother who lived with us was very important in shaping my attitudes towards life, especially during my early childhood. She was a clever woman. She loved reading and told me many old stories about the history of our family and the surrounding community. At the age of thirty-six, she was partially paralyzed by a stroke, but lived until she was sixty-nine. Since she required constant attention, my father expected my mother to be a constant caretaker. The situation was difficult for both my mother and grandmother, even though at that time in Japan it was the social norm for the wife of the first son to take care of his parents. It was by observing my mother and grandmother's lives, that I was motivated to find a different life for myself.

My mother was a smart woman. She was also a perfectionist. She used to sweep every morning and every evening. Every drawer was neat. She had her own way of doing things, and if things didn't satisfy her she was unhappy. On the day of my father's funeral, neighbors came to help. They cooked and cleaned, but after they left, my mother and sister went to the kitchen and cleaned everything again.

Once my father told her, "People respect you more if you sometimes let others help you, even when you know that they will not do as good a job as you would." My mother never learned that. Just after her fortieth birthday she began to suffer from a bad case of rheumatism. It still makes me sad to think of how much she suffered. I was sad when she died, but also relieved that she no longer suffered.

MM: My mother was the same. She let my father enter the kitchen only to wash the dishes after a meal. The kitchen was her kingdom, and she did everything in it efficiently and well. She was not a great cook, but she was a wonderful baker. She made all the family's bread, and every Saturday she made fabulous cinnamon rolls. When Mother died, a neighbor brought a casserole and told my father, "All you need to do is put it in the oven." So that's what he did. He didn't turn the oven on; he didn't know how! I don't know how my father managed after Mother died; I was on the East Coast and he was on the West Coast. Until he remarried three years later, he lived alone and was terribly lonely.

Part I: From There

HS: In a time in which there was tremendous economic expansion and cultural excitement, I had no specific career ambition, and I was free to do whatever I wanted. I was lucky to have been born a girl! My father and uncle had a business that sold agricultural equipment; if I had been a boy, I would have been expected to carry on that business. When we were asked at school what we would like to be, I always said that I wanted to be a teacher. But I was very interested in television and newspapers and what was happening in the rest of the world, so I thought that becoming a journalist was also a possibility for me. Or I thought that I could work for an international organization like the United Nations. At the time, import-export companies were popular, so I thought I could work at one of them. Each of these possible careers was related to the big world beyond the mountains. If none of the careers to which I was attracted worked out, I thought I could always try to find a man.

I did not dream of a career that depended on my looks. I was very self-conscious; I thought that I didn't have a beautiful face or a body that could attract boys, so instead I studied. I told myself that intelligence was more important than looks. In fact, when I was in junior high school my father even told me, "Hiroko you don't have big breasts so I think you should study hard, because that's the way you can get on in the world, instead of being cute or sweet."

When I was fourteen, I saw a documentary about Japan's women's volleyball team that won a gold medal. I really enjoyed seeing how demanding the male manager was; he devoted his entire life to the players. I would have loved to be his wife. The idea of being the "invisible" supporter of a man like that, combined with the influence of those American home dramas, was very powerful propaganda.

I felt that something was missing. I was a good daughter, sister, and student, but until my early thirties I also felt that I was a pretender. I could *act*; but it bothered me that I wasn't being true to myself. I wanted to be independent, but I was not brought up to determine my own life. The first time I insisted on what I really wanted for myself was many years later when my husband was preparing to return to Japan from San Diego. I told him, "I am not going back to Tokyo with you." But that is ahead of the story.

Wanting to see the world motivated me to study English. So when a Catholic boarding school opened a few hours' drive away, I applied for a

scholarship and persuaded my parents to let me go there. Because I was so focused on learning English, I did not take advantage of the fact that the nuns who taught me were native Spanish speakers. Instead of learning Spanish, I learned English from Spanish nuns!

MM: So your parents encouraged your curiosity and your efforts to get the best available education. My parents were fearful of my curiosity, which, they believed, could lead only to my departure from their values. They were ambivalent about education, on the one hand valuing it highly, on the other, fearing that education could damage my soul. Later, they were similarly ambivalent about my teaching at Harvard. They were proud of my achievement, but feared that I would lose my soul in that climate of progressive ideas. My parents' worldview, as immigrants, as religious conservatives, and as people who married during the Great Depression, emphasized that there was "us" and "them." I had no sense of a large and various world in which there were many possibilities for me.

What came next for you?

HS: I became less interested in getting good grades in all my subjects; I began to concentrate on English, literature, and history. During junior high I had been the top student of English in my class. I was able to anticipate rather accurately the questions on the exams by trying to imagine what I would ask if I were the English teacher, and I always got one-hundred percent in those exams. Yet my speaking skills were not good at all because all the emphasis was on grammar and reading; I envied my friends who could say, "Hi! How are you?"

Japanese teachers assumed that there was only one right answer. Because many teachers did not speak English fluently, the answer to any question was limited to what they understood. I began to question why we were always taught the one right answer, inhibiting creativity. This was one reason that I later became interested in studying design; in design solutions to problems could always be found, but one could not predict in advance what the solution would be.

> "Live as if you were going to die tomorrow, and study as if you were going to live forever."
> ~ SENECA

Part I: From There

MM: So you were restless, and *knew* that your education was constricting! This is amazing, because you had no experience of other ways of learning with which to compare your education. But somehow you understood that there must be other ways of learning and you wanted to find them.

HS: In my junior year at boarding school I applied for an American Field Service scholarship, which at that time was the best high school exchange program. I was among about a hundred students from all over Japan who were chosen for the program. I came to the United States and spent one year at Collegiate School in Virginia. The first thing I learned was "Hi y'all!" I lived with a host family who had a daughter my age and an older sister who was in college at the time. The father was a professor at Union Theological Seminary in Richmond. The mother was a housewife who taught religion once a week at our school. I had a great time with them. It was a dream family. Every night we had dinner together; the food was always delicious and the father made sure everyone had enough. We talked about our day, and the parents always listened attentively and were there for us whenever we needed them. Every night my American sister kissed her parents good night. The family provided an ideal model of marriage and family life for me.

My school life was full of events and fun, but my high school teachers in Richmond were real educators; they didn't spoil me. I was treated just like the other students, so with my rudimentary language I struggled a great deal at first. But that year, when I was seventeen and eighteen, taught me to feel comfortable living in two cultures. Of course I was, and am, rooted in Japan, but now I have one foot in Japan and one foot in the United States and other countries. The freedoms, options, and choices really opened up.

MM: So you were in the United States for one year and then you went back to Japan?

HS: Yes, I didn't graduate from high school in the United States so it was assumed that I would go back to my old high school in Japan and study an additional year in order to graduate. But I didn't want to do that. I wanted to go to the International Christian University in Tokyo. Before I

went to the United States I had gone to the admissions office and gathered information about applying there. I was really organized! And brave! So I went to the principal of Collegiate School and told her that I needed a diploma in order to apply for the university. They counted the credits from my Japanese high school and the credits from Collegiate, and they were enough for me to graduate, so they gave me a diploma. I saved a whole year that way.

 I didn't know, until I went back to Yamaguchi and read my mail, that ICU had accepted me. My American father had written a very strong recommendation for me. So one month after I returned to Japan I entered the university. I took classes in art, philosophy of religion, philosophy, and introduction to Christianity. I majored in English and wrote my thesis on Emily Dickinson. Those subjects gave me the basis for what I do presently.

MM: It sounds as if you were motivated throughout by curiosity combined with a good dose of courage and a lot of energy. Perhaps curiosity is another word for delight. You found the things that attracted and excited you and you pursued them ardently. Another aspect of your story that interests me is that you always actively sought the best educational opportunity you could find. You did not just accept the nearest school, the school all your friends went to. Your commitment to activity rather than passivity was, I think, absolutely critical.

> "The happy life is thought to be one of excellence; now an excellent life requires exertion, and does not consist in amusement."
> ~ ARISTOTLE

HS: Soon after I got married I got my first teaching job at the American elementary school in Tokyo. I taught Japanese for two years. Then I had a baby, and I didn't teach again for six years. My husband and I went to San Diego and I completed a master's degree in applied linguistics, teaching Japanese language and culture as a full-time lecturer for two years. There was a language institute on the same campus where many Japanese students studied English. I coordinated occasions outside the classroom where my students of Japanese language and culture could meet native speakers of Japanese in a social setting. I created a bridge between the two cultures for the benefit of both Japanese and American students.

Part I: From There

MM: Oh, that sounds like the beginning of your present career!

HS: Yes!

MM: Americans have a stereotype of Japanese women, that they are very shy, but you weren't shy at all!

HS: I am shy in some social occasions.

MM: Oh, you are not!

HS: Yes, I can't dance, for example. I'm also shy in that I don't know how to relax in big parties unless I am in charge of them and I know who I need to introduce to whom, and what I need to say.

MM: In youth, one is attracted by all possibilities that cross one's path, afraid that something will be missed. Of course, that is also how a person learns to be discerning, by trying many things and gradually focusing on opportunities you recognize by your inner delight. Instincts become more trustworthy as you get older and have done good work. You don't have to worry about your decisions quite so much.

I notice that speaking more than one language has been important in both of our careers. For me as an academic, each language I have learned has opened to me another literature with new authors and ideas. Of course, original languages are expected in graduate work, writing, and teaching. Translations are already interpretations of texts, so it is important not to rely on others' translations, but to read the text in its original language.

When I decided to undertake a doctoral program, the only language I knew other than English was French. I had learned French because I had lived in eastern Canada and picked it up there. My parents spoke French when they didn't want us to know what they were saying, so that was great motivation for learning French! But Canadian French sounds strange to French people, so I try not to speak it when I am in France. I think I sound just like them, but they don't like the sound of it!

Growing Up

"Life is too short to devote much of it to activities that are not at the heart of what it is to be human."

~ Martha Nussbaum

When I was fifteen and living in Seattle, I was very bored with everything because my parents had strict rules about what I could and could not do. They were immigrants to the United States from Canada and fundamentalist Christians. They felt that the United States was an alien place, characterized by wrong values and spiritual and moral danger. Also, they had married during the Great Depression of the 1930s, an economic situation that frightened them permanently.

My father, a Baptist minister, suffered from depression, so I learned very quickly to sense the atmosphere of the house when I came home from school. If he was happy he could be fun; if not, he could be very difficult. Moreover, my parents' generation seemed to think that they owned their children. My father told me that when I grew up I could be either a missionary or a professional violinist. He had wanted to be a violinist when he was young, and was not able to, so he thought that my life should fulfill his dream.

Every child's first concern is getting and keeping her parents' love, and I felt their love to be so precarious that it could easily be lost by a misdeed. Thus, as a small child, I learned to lie. Because almost anything I wanted to do was forbidden—eating candy, playing, or reading comics on Sunday—later, going to movies or plays at school. As I grew up, lying became habitual. As an adolescent earning babysitting money, I was supposed to send the money to missionaries. When instead I bought clothes with the money I earned, I said that a girl at school gave them to me. I saw my first movie at age seventeen; I stayed overnight with a friend and we went to see *The Glenn Miller Story*.

By the time I was eighteen I had become a very skillful liar, which came in handy when I became pregnant. My father had a colleague whose unmarried daughter got pregnant, and my father had told me that if this ever happened "to him," he would never preach again. So of course my fiancé and I lied. We got married, and when my daughter was born seven months later, we said that she was premature. My gynecologist agreed to put the wrong weight on her bracelet. She didn't look like a premature baby; she weighed seven pounds, twelve ounces, but her bracelet said five

Part I: From There

pounds, two ounces. However, wanting desperately to believe our lie, my parents did. Later, in psychotherapy, I had to learn to *stop lying*. Even now, I work hard in large and small things to behave in such a way that I don't feel tempted to lie about it.

My parents were always full of apprehension and fear that I would "turn out" wrong. They told me they loved me, usually when they spanked or otherwise disciplined me: "We're doing this for your own good, because we love you." Their religion taught them that a child is by nature wicked and that the only hope for the child was for the parents forcibly to obliterate that evil nature. Years later, a high school friend told me that she always thought that my parents didn't like her. I realized that I also thought they didn't like me. They loved me, but they didn't *like* me. As an alternative to earning their *like*, I tried to make them proud of me.

I had no idea that there was a large world around me, full of possibilities. I sneaked looking at magazines like *True Love* that pictured romance as rebellion, as the ultimate excitement. For me, getting married at eighteen was rebellion. My parents didn't want me to get married; they wanted me to continue my education. Marriage was a way out of my fundamentalist socialization, but it also landed me directly in a different set of social expectations and duties. By the time I was twenty-one I had two children.

HS: So marriage was a way to escape from your parents.

MM: Yes, exactly. I am so grateful that I never learned to type, or I would probably still be someone's secretary. Since I had no marketable skills, I went to school! I'm also grateful that I was not happier in my first marriage, or I would have stayed. But I was unhappy enough that I needed to leave. When I was twenty-two I had an ulcer that threatened to perforate. It was painful enough, and I was young enough, that with the help of seven years of psychotherapy, I was able to change fundamentally.

Two incidents that became wake-up calls for me occurred at the same time as my ulcer. One summer morning my friend Jeannie (who was thirty years old) woke up when she heard her four-month-old baby cry. She had convulsions for thirty seconds and died. She was a healthy young woman; the only advance warning of her death was a small headache the evening before. Her death was not the primary wake-up call, however:

Within four months her husband remarried. For the first time in my life I realized that placing all my energy and hopes in serving my husband and children might not be enough to produce a fulfilling life.

At approximately the same time an acquaintance who was a beautiful and talented lounge singer attempted suicide. Her fortieth birthday occurred and she realized that sooner or later she would lose her looks and her voice. Her suicide attempt prompted me to decide that when I came to be forty, I didn't want to be thinking about how I looked. I wanted to be doing something so interesting that I would not worry about my birthday.

Have you had any powerful wake-up calls that altered the course of your life?

HS: Yes, two. The first one came when I was seventeen, when I first went to the United States as an exchange student. Before that, as I said, my introduction to America was solely from television. I thought that my life in the United States would be totally different from my life in Japan. But what I found out was that even there I woke up, brushed my teeth and . . . *I was the same*! I realized that there is no utopia, that you really just have to get on with living your life wherever you are.

My second wake-up call came in my early thirties, when I returned to Japan from San Diego. I was showing a Japanese guest around Yamaguchi, my birthplace. I took him to the pagoda, which dates from 1433. I suddenly realized it had been built before Columbus discovered America. I had thought that America was the center of culture and technological advances, the powerhouse of wealth and exciting lifestyles, but look! this pagoda was built before Western civilization had even reached there. I realized I had to learn about my own culture, and not just be fascinated by foreign countries. I needed to know my own culture in order to know those other cultures.

I grew up expecting that the world was ruled by wise men who would always lead us in the right direction. My elementary school teacher told me that our country would never again make such a mistake as World War II, and that since Japan had no natural resources we had to develop our human resources. But as Japan's economy began to escalate in the late 1950s, environmental pollution became a very serious issue. At the age of sixteen I became disillusioned about the men who were leading us. It was

Part I: From There

a bit like realizing that Santa doesn't exist. It made me aware that everyone has to take responsibility for his or her community.

How did you pursue your education?

MM: By the time I completed my MA, I was married to my second husband. We both taught at several California community colleges. The district had a rule that only one member of a family could have a full-time job. So of course it had to be my husband. Since I was a part-time teacher, and had my degree in humanities, it was assumed that I could teach anything. So I was assigned at the last moment to teach courses as disparate as world religions, semantics, or English composition. It was not a satisfying teaching experience; I thought that if I got a doctorate I would be able to teach something that I actually knew something about! So I entered a doctoral program.

I continued teaching at a community college in the Sierra foothills three days a week, and I commuted 140 miles each way to Berkeley twice a week. I learned vocabularies of the four required languages on the commute to Berkeley, reserving desk time for learning grammar. It worked for me, though I have never recommended that students learn languages while driving! When I think back to that time, I am amazed that I was able to do it. You had to be young! In short, I eventually got a job teaching at Harvard by a combination of luck and passion for what I was studying, in other words, by chance and choice.

> "We are all teachers. And what we teach is what we have to learn. So we teach it over and over again until we learn it."
> ~ Faye Sultan and Teresa Kennedy

Today, when opportunities come to me, I endeavor to discern whether I can both contribute and learn something from them. For example: when you, Hiroko, and two Buddhist priests came to my home in Berkeley to ask me to write an essay for the Shinjo Ito exhibition catalog, I thought at first that you were talking to the wrong person. I am not an expert on Buddhist art, or even Buddhism. But as we talked, and as you told me your interests and concerns in creating the exhibit, I saw that there were connections with what I have studied and thought about in terms of the use of vision in Western religious practice. I realized that it would be a

good exercise for me to consider religious images in another context than that of Christianity. I had to do a lot of reading, but that was good. I didn't want to just keep doing what I already knew how to do.

2

Socialization

MM: Let's talk about how, as children and young people, we were pressured, subtly but strongly, by our parents, our peers, and our society to certain behaviors. What aspects of these pressures did we endeavor to change or revise in adulthood?

Like you, Hiroko, I was told that I needed to take care of everyone—family first, but also anyone in my vicinity who was needy. This demand was put to me quite specifically as a religious duty: "God first, others second, me third." My mother was so intent on caring for people that she invited for dinner only people who could not invite her back, needy people, people she thought she could cheer up, make feel better, or whose loneliness she could relieve. She intentionally did not invite people she liked and wanted to spend time with. Helping others was one of the primary values of her life. But she didn't take care of herself at all; she didn't know how. She became tired and burned out regularly. I do not remember her as a happy person.

HS: I don't remember my mother as happy or unhappy. She just did her duty. As I have described, she served my grandmother, she worked for my father as an accountant, and she also cooked for some of his young employees who lived in the company dormitory, a sort of extended family.

What did your mother do as a career?

MM: Until all four of her children had left the home, she worked at home. She (and my father) thought that she should not leave the home. She wrote Christian devotional literature for children that sold many more copies than my books will ever sell! But her books are so guilt-producing that I hid them from my children!

When Mother was dying of a brain tumor and had not spoken for several days, she suddenly said to my sister, "I'm happy." My sister was very surprised because we had never heard our mother say such a thing. I think that only then, close to death, was she relieved of her obsession with caring for others. I have always felt sad that she could only be happy when she was so close to death.

For me, taking care of all the needy others in my vicinity became impossible when I was teaching dozens of students, each of whom had particular needs, both academic and personal. So I had to revise that expectation. I put in its place the conviction that my life was as important as others' lives, not more, but not less. I try to create a balance between making sure that my own life is rich and full, and then doing what I can to care for the needs of others. This requires constant attention because needy people are everywhere: at home, at work, and in public places.

The philosopher R. G. Collingwood's definition of duty has been helpful to me. He said that duty is "that which I, and only I, can do in this, and only this, situation." But it's even more complicated than figuring out what I "can" do. It requires me to know myself sufficiently to discern what I *can* do without resentment or burning out. Nevertheless, I acknowledge that I have not overcome in myself the expectation that others' needs require my attention and action. What human beings can do to help one another is so small, so *not-enough*, that when I see something I *could* do, I feel I must do it, even if I *can't* do it without stress and, eventually, resentment.

HS: My family was typical for Japan at the time, in that the family unit is the most important thing, not any one of us as individuals. But in practice, the oldest son is always the most valuable child. He inherits the house and property, usually with the unwritten promise that his family, in turn, will care for his parents when they get old.

My grandmother's religious practices were also part of my socialization. She was a very devout Buddhist who prayed at the family altar every

morning and evening. My parents were not very religious and didn't push me toward any faith, although annual grave visiting was important, and if we ever received a gift of food, we always placed a portion on the altar first. As I mentioned, my grandma was disabled from a stroke. She walked with a bad limp and I remember wishing that I had a more stylish grandmother when she came to our school sports days. I must have mentioned this to my father because he became furious and told us, "Don't you ever, ever be ashamed of your grandma." Sometimes as a punishment he would order us to take a bath with her, to wash her back gently as a way to show our respect and affection.

MM: I have come to recognize that there are things I *can* do—without resentment—such as caring for dying patients as a hospice volunteer. And there are things I cannot do that may seem to someone else to be much easier than that. But I can't do them, and must simply acknowledge that I can't.

Often I offer to massage my ninety-three-year-old hospice patient's feet because they get dry and itchy. She says, "Oh, you don't want to do *that*," but I assure her that I do. And I do. She loves to have her feet massaged very slowly and for a long time, and it gives me pleasure to give her that pleasure. Our relationship is reciprocal; I learn from her experience. She is a Russian Jewish woman who, when she was a young woman, saw her father shot to death by a burglar in his small business in Chicago. Her mother and brother collapsed in shock and grief, so she quickly learned the business in order to support the family. She said, "I would have loved to fall apart but I didn't have time!"

From this experience she learned that one can *choose* to be strong in a particular situation. It isn't that one either is, or isn't, strong; one can choose strength. Choosing to think of oneself as a helpless victim is neither necessary nor helpful. Each day when I leave my patient she says, "Be strong!" Even bedridden, with poor eyesight and hearing, and loss of bowel and bladder control, she is still a strong woman. She hires the help she needs to be independent of her son and daughter, makes grocery lists, and is resolutely cheerful. Within the physical constrictions of her life, she maximizes her strength.

HS: There were always many of my father's employees and clients in our home, so I have never been afraid of meeting people. It really doesn't matter who it is, whether it's the king of a country or a homeless person on the street, I can communicate with them. When I was little I was often told I was too nice to everybody. I can't stand quarrels or fighting or arguments, and I find it very hard to confront people. As a child and young person I tended to just step away; then finally, much later, I learned to say no in a polite way when necessary. Now I am a producer, and producers are expected to say yes or no very clearly.

> "Things don't have to be perfect. In fact, it is better if they are not."
> ~ JESSICA BENJAMIN

MM: We are alike in that way. Once my daughter said to me, "Mom, you treat people like persons who don't treat you as a person." That observation was helpful to me. It did not make me want to treat others less as persons, but it did encourage me to insist on being treated as a person myself.

HS: There is a big difference between my career and your former career. When you work in a large academic institution you cannot choose the people with whom you work. In my case, I own my own small company, so I can be very straightforward about staying away from people I don't want to be around. And, because my socialization demands that I be nice to everyone, it is especially important for me to stay away from people I don't get on with. When I like a person, of course, it is easy.

MM: One of the most difficult social and personal problems entailed by changes in our societies is the question of who should care for the young, the old, and the sick. Since women have begun to participate in the public sphere by working outside the home, it is no longer clear whom the caregivers are or should be. The answer is not for women to get back into the home, but there's a gap between the need for care and the number of caregivers. Since there are no longer "natural" caregivers, perhaps governments should provide institutions that offer really good care.

Part I: From There

HS: In Japan the expectation that the wife of the oldest son will take care of the old people is still sometimes a tremendous burden, one that continues for years. One of my friends in the baby boomer generation, even though she was not the wife of the oldest son, took care of her husband's parents beginning as soon as she was married until recently, when the last parent died. She cared for her mother-in-law for over forty years. I respect that, but I just couldn't do it. In fact, the damages were profound, although she was not aware of them until her own daughter developed an eating disorder, a symptom of the resentment that circulated within the family.

MM: How did she come to be designated as the caregiver, since she was not the wife of the oldest son?

HS: Partly it was because they lived in the same town and even in the same house with his parents. The son and daughter-in-law who lived with them were the ones to care for them.

MM: Did she accept this as a vocation, her way to help in the world, or was it a terrible burden for her?

HS: She just accepted it as her responsibility. She is also a very creative person who had many interests. She is a doll maker, and she teaches, for example.

Her daughter used to tell me stories about the fights between her mother and her grandmother. My mother and grandmother had a similarly stressed relationship, and I told myself I would never get into the same position. As the wife of the oldest son I am lucky that my parents-in-law are very independent. They don't rely on us; they found a good nursing home close to the ocean and they live there very comfortably. So we can have a happy and spontaneous relationship with them because we don't care for them on a daily basis. It was their decision after going through the same situation themselves. When my father-in-law, the oldest son, built his house close to his workplace in his early forties, his parents sold their house in Kyushu and came to live with them. My husband's parents wanted to find a better way to deal with this important issue and chose to live independently.

MM: You *are* lucky! You don't have to take care of them, and you don't have to feel guilty. When my parents were old and sick, I was teaching on the East Coast and they were on the West Coast. Fortunately, my sister is a saint, and one at a time she took care of my parents in her home until they died. My father was the last to die, and he was with her for a couple of years while he was having increasingly debilitating strokes. I am so grateful to her. When my father died I managed to speak at his funeral because I wanted to thank her publicly for what she had done on behalf of all of us. She did it without resentment too. It was a beautiful thing.

It is wonderful if there is someone in a family—or even a friend—who can consider it a vocation to care for those who need it. Rather than having a person shape themselves to a role, the role can come to the person most suited for it. This is so much better than designating a particular caregiver because of their position in the family, a person who may not be at all suitable for the job. This is true not only of caring roles, but of all roles—gender roles or sexual orientations, for example. If people can choose among a very broad spectrum of roles, they will be happier people. And happy people are generous people; unhappy people are not generous.

> "Delight is, as it were, the weight of the soul. For delight orders the soul.... Where the soul's delight is, there is its treasure."
> ~ AUGUSTINE

HS: Yes, the best way to help others is to be motivated by delight. For example a friend took slightly early retirement in order to care for several people, including her mother. She is a single woman without children, and she took pleasure from knowing that she was needed. She enjoyed cooking with fresh vegetables for them, finding cheerful clothing, and taking them for walks. She found creative ways to enhance their quality of life until they died.

MM: In my training as a hospice volunteer, patients were referred to as "dying people." I protested that they are not dying people—any more than their caregivers are—but living people! Our job is to help them enjoy the best possible quality of life each day.

Part I: From There

HS: Japanese society is recognizing that many problems are caused by the old system of designating a family member to care for those who need it, and creative alternatives are being sought. Now in Japan we have a rather new, and still struggling, system of public care. This will help to relieve the burden on the family member who is expected to care for the elderly and/or disabled. Another solution might be to create a small community of people who can care for each other and complement each other's skills. When they need more intensive services, there are affordable nursing services. People need to have choices so they can find what best suits them.

I am still trying to figure out, given my life and its demands, how I can help people. At present I don't need to feed any particular person.

MM: Yet you do feed all the people who work for you—approximately one hundred employees in each exhibition—by keeping them in work! And by treating them as people whose work is valued, whose role, no matter how small, in producing the exhibition is essential to the whole. You are a very giving person. It is woven into your manner, your ways of working with people, and your conversation. You make people happy by recognizing their talents and giving them the opportunity to exercise them.

HS: This is very helpful. Perhaps you are right that I am helping people in my own way. Being helpful to other people is a way of saying, I am happy. It's not charity; it is giving a gift, with all the pleasure the giver gets from that.

MM: Moreover, helping others isn't only a matter of doing large and small things for people. It must be understood much more broadly. For example, the Buddhist art exhibition you produced was helpful to people. One could see on the faces of the people who visited that they were enthralled, excited, and thoughtful about the artworks. They were helped in their lives by the exhibition. That is one of your primary ways of helping people. It was the same with me when I was teaching. I was working almost entirely with doctoral students who were well prepared with languages and research tools. But I could help students take the next small

step toward understanding and articulating something. They still needed someone to have confidence in them.

For both of us our primary helpfulness is embedded in what we do, or have done, professionally. At present I have time to do special things like hospice volunteering only because I have retired from a profession in which I acted as a critical friend. I helped people through a rigorous and demanding preparation so that they could enter a profession in which they would pass on the care and attention they had received to others. In academia, you are seldom able to return favors; you pass them along to the next person who needs them. Often, when a student apologized for asking me for a letter of recommendation or thanked me profusely, I said, "Do you think I got here with no letters of recommendation? I'm simply passing along what others have done for me."

Life and work are not separate. You give because of your training and expertise, in a way that others can't. We each need to find our own way that is not confined to the traditional idea of charity. "Charity," at least the way the word "charity" is presently used, is the opposite of generosity.

HS: I guess my profession is my way of trying to be helpful.

MM: Yes, so why don't you notice that you are helping others? Because it feels good to you too, and we assume that if we are doing something for someone else it should feel at least demanding, if not unpleasant? But I think that what feels good to you as well as the recipient *is* real giving.

A question I was frequently asked when I was teaching was, how do you keep your work and your personal life from intruding on one another? This question always puzzled me because I did not find work and personal life so different. It was all *my life*, and I didn't try to keep work separate from my personal life. When you are working out of delight, it unifies one's life, keeping conflicts between life and work minimal and temporary.

> "Benevolence is good, but when is it a moral mistake?"
> ~ Iris Murdoch

Helping others is, however, always a complicated matter. In some situations, benevolence is a mistake, in personal as well as professional

life. When my son was a young adult and was having a difficult time finding his niche, I gave him money. He needed to eat. But my providing for him implied that he couldn't manage on his own. What they call "tough love" is sometimes the kindest thing, demonstrating a deep caring for the person and a confidence that he can do something for himself—and sending the message that he'd better!

I have a problem with admonitions to help others. I want to say, all right, got *that*, now help me discern when benevolence is actually beneficial to the person "benefited," and when it is a mistake. Perhaps no one can provide general guidelines; perhaps everyone must simply work out in life, *on location,* when generosity is one or the other.

HS: Many people cannot think about others because they themselves have many problems and little bliss to nourish them. Young people in particular often have too much anxiety about establishing themselves to allow generosity to others.

MM: I do not envy the young. They have beautiful bodies, but they also have too much pressure to find their niche in life and to achieve. I feel great sympathy for them. Think of the anxiety of not knowing what is going to work out for you, what life will bring your way, and not being sure that you are doing something for which you have talent. At several times of life it becomes almost necessary to be self-absorbed, to put most if not all of one's attention on oneself. Youth is one of those times, and perhaps extreme old age, when the failing body demands attention.

> "It is difficult enough to breathe in and out, remain vertical, and remember one's temporary address."
> ~ Kate Braverman

It is interesting that we have talked so much about helping others. It must still be enormously important to us, even though we have revised our ideas about how to do it. It must be a rather important part of our self-image, a part of our socialization that sticks with us!

3

Relationships

HS: In Japan men's and women's relationships are changing quite a bit. For one thing, young girls are becoming more independent; they are much stronger, emotionally and even physically.

MM: These are great changes, but there are also some damages from them. For example, my son's grandfather was an alcoholic, but his wife took care of him. She worked, she cleaned, she cooked, she did everything, and his grandfather just hung around and drank. When my son, who also became an alcoholic, was in relationships he expected to be taken care of as his grandfather had been. So although it is good that most young women are no longer content to do everything for a man, some men's expectations have not kept up with this change.

> "Each torpid turn of the world has such disinherited children, to whom no longer what's been, and not yet what's coming, belongs."
> ~ Rilke

HS: Women can take care of themselves, while many men feel that there should be someone else devoted to their care and maintenance. Usually that is a woman, but now that woman is often also working outside the home!

Part I: From There

When my husband and I married I was a senior at the university. After our two-night honeymoon in the countryside, I had to come back and finish my thesis. At that time we lived in a married student dorm, which is very unusual in Japan. Our friends would come over every night. My husband was a support for me. We were of the same generation and similar social environment. Although he is from Kyushu, where the men are famously chauvinistic, he encouraged me when I began teaching. But later, when I began putting so much time and energy into new projects, meeting new people and traveling abroad, it was difficult for him and he was resentful. Looking back I realize that it must have been very hard for him to be married to me. In the beginning I tried to be subordinate and traditional, but I have a strong nature and my own way of doing things; I think he was surprised to discover that I was more independent than he had expected. When I became active outside the home he didn't complain, even though he felt the pressure.

My husband is a traditional Japanese male in many ways. Eight months into my first pregnancy, when I quit teaching, he suddenly announced, "At last I'm the family's only breadwinner." He wasn't trying to be mean, it was simply a fact. But I burst into tears. Why? I was married; we were going to have a baby; I thought I was happy; I thought I had everything I wanted, but the fact that I burst into tears revealed that I wanted something more in my life. I was twenty-four at the time; I did not make a choice for my own life until I was thirty-three. It took me almost a decade to know myself sufficiently to take action. I wanted to remain in the United States with my children to pursue opportunities that came my way. I was simply not ready to return to Japan; I needed another year at least in San Diego. I had only just rebuilt my teaching career and I had to feel that when I got back to Tokyo I could start again with something concrete.

I wanted to have a very different marriage than the one my parents had, and eventually I did, but that inevitably involved compromises. In Japan it is common for men to socialize after work as my father did, expecting their wives to take all the responsibility for the household. When my husband left the house in the morning I never knew when he would return. I thought that it was unfair that I was always the one to stay home. One night, when my husband had not returned by 11:00, I decided to punish him; I wanted to make him miserable. I had two wicked ideas. One

was to lock the door from the inside so that his key would not work and he would have to plead with me to let him in. The other idea was to have a bucket of water ready to throw on him when he entered the house. When I heard the door click after midnight I dashed excitedly to the door to put my plan into action. Alas, to my disappointment, he managed to open the inside lock, and he ducked when I threw the water! Years later he told me that he realized then how frustrated I was in my confinement, and he felt that he had to find something in the world outside the home for me to enjoy. So he started introducing me to people who gave me part-time jobs.

Before getting married I thought that a husband and wife should share everything about their lives. But one's late forties are a tough period for any marriage, and after those difficult years I came to believe that you're lucky if you can share just one percent of your life with each other. The important thing is that the bond is not cut, that you maintain a connection.

We married for love, but over time I came to believe in a very sharp distinction between love and infatuation, despite all my ideas from romance novels and American television. When our marriage was endangered, when my husband took an apartment and began living there, and told me he was seeing another woman, I just told myself: *let it happen. Do not overreact; don't make yourself the heroine of a drama.*

I believed that instead of confronting him and creating conflict, we could work it out, that as long as the ground under us was relatively firm we'd be fine. I still think that. I don't regret anything.

Presently, my husband lives in New York, and I am mostly in Tokyo. We do not live together, but my husband still understands and supports me. He loves to see me developing in new directions, and is very proud of me.

MM: Is your practical approach to marriage common in Japan?

HS: Yes and no. At first I saw marriage as being all about romance, but I learned that it is a social unit, with children and responsibilities added. We needed to find a way to maintain a bond between husband and wife, and also between parents and children. Children need the support of both parents in order to function well.

Part I: From There

What strikes me about many Western marriages is that couples often divorce when the romance is gone, and that is understood as an acceptable reason to find a new partner and start again. People feel entitled to romance. The Western approach to marriage seems to lack creativity. I try to work with what I have; even if my relationship is difficult, I am committed to finding a way together. I wanted to have the independence and freedom to create a new style of family based on old values yet remaining open-minded and very positive. That was my ideal.

MM: At least for women of my generation, "romance" seems to be linked with sex. We often talk about romance when we actually mean sex. Romance wanes when sex fatigues. American culture is fascinated with sex, and values it above many other values that have longer shelf lives, forgetting that for many people in the United States and the world, sex is unwanted, boring, exploitive, or destructive. Sex is not an unambiguous hedonistic "good" as popular culture pictures it. Women have always feared unwanted pregnancy, and for the past thirty years or so, STDs and AIDS have made sex dangerous for everyone. Every year in my annual physical check up my doctor asks me if I practice safe sex. I say yes, monogamous heterosexuality. She says, "That's not safe sex," for one's own sexual behavior does not guarantee that one's partner's behavior is the same.

Even during the promiscuous 1960s, before AIDS was a danger, sex was exploitive for many women who were accused of being "cold" if we refused to have sex with someone. Sex is an excellent example of Michel Foucault's axiom "Everything is dangerous." Even the best of human experiences must be carefully protected against harm to the individuals involved. By the way, religion is another great example of Foucault's axiom, but we'll get to that later!

HS: Loneliness is a problem in Japan. Of course, it's very difficult when a husband passes away, but widows live longer; they have fun; they do whatever they want to do. Widowers tend to live shorter lives.

MM: I read somewhere that the kind of person most likely to commit suicide is an unmarried man. Because he is lonely. Because he doesn't know how to take care of himself. Men too could diversify and find new

activities and pleasures. But many don't. As little boys they have been taught to focus. They are urged to decide on, and begin to cultivate, a profession when they are very young so they never develop a variety of interests and pleasures. And when they are elderly and their wives die, they are still focused, but the reason for their focus—usually a job or profession—has disappeared. And they haven't learned to derive satisfaction from doing anything else.

HS: I really don't understand why men and women are so different, even though we are born in the same society.

MM: I think it's because we are socialized not only differently, but oppositely. I'm resentful that women and men are socialized in ways that make relationships very difficult. I know three men who are about fifty years old; they have never been married, and they are not gay. They are very proud that they have never been "caught." But to me their lives look stuck and bleak. Their attitude toward marriage as a trap is created and reinforced by advertising and media in North American culture. The ideal man is pictured as autonomous and independent; he answers to nobody. When this is the model of what it means to be a "real man," men feel compromised when they have a relationship with someone, when they have to be faithful to somebody. They see it as a limitation of their prerogative of independence.

Women, on the other hand, are socialized to develop close relationships, to be defined largely by their relationships, to take care of people, to stay with people. We were brought up to think of relationships as our definition and destiny. So women are socialized to relationship and commitment, and men to avoiding relationship and commitment. These models of masculinity and femininity are strong, and they are reinforced at myriad points in media cultures; they make it extremely difficult to have strong and lasting relationships. My first two marriages suffered from the disconnection between male and female expectations.

Many men *need* women, but they don't *like* women—perhaps *because* they need them. They also feel resentment; they do not like the feeling of dependence. So they try to believe that they are aggressively independent, lords of the earth; but they cannot wash their own socks! My husband is better now, but he used to panic in the kitchen. When I was away, he was

likely to call me to ask me how long he should boil an egg. He could look it up; there were plenty of cookbooks in the kitchen. He is accustomed to doing difficult academic research, after all. There's a great line in Alice Walker's *The Color Purple*; the women are sitting around telling stories about the men and one of them finally sums it up: "Ain't they somethin'?" Many younger men are not like that. We brought them up better than that!

Women bear part of the responsibility for men's domestic helplessness. *Because* we have been willing to take care of men, they have not acquired the skills they need for everyday living. What can we do to help them change? What needs to happen for men to adjust to doing their share of the work of daily life? I have tried to address this by gradually doing more of the jobs my husband has done for many years: the taxes, taking care of getting the cars serviced, yard work, and so on. I hope that he will notice and volunteer to do more of what he considers my work. We'll see how that works out!

I have mentioned that when I was twenty-two, with two small children, I was hospitalized with an ulcer that threatened to perforate. As a result I started seven years of psychotherapy. Almost immediately the energy that had been chewing my stomach lining went to my head and I began to read voraciously. Then I began to take courses at the nearest community college. Going to school was a lifesaver for me, but my first marriage ended because I refused to stop going to college. My husband had, in fact, married a different woman than the one I became. He wanted—and expected—to have a wife who would leave the home only to support his work. I changed, and I felt that my husband could not be blamed for wanting the wife he married, so I did not oppose his leaving and divorcing me.

Years later, my second husband told me that he wanted to have an "open marriage." This meant that he wanted it understood that he could have sex with whomever he wanted whenever he wanted. This arrangement was not unusual in California in the 1970s, but I did not want it. So we separated and divorced. This time, I divorced him. I took a class in which I learned how to manage my own divorce!

I cannot fully explain why my first two marriages did not work. Perhaps it was partly that I did not heed my mother's warning that it would make my husbands unhappy if I got higher academic degrees than they. Perhaps it was partly because, in the competition my husbands set

up between attention to work and attention to them, work usually won. I wonder if many people's lives feature this very rich and somewhat dizzying mixture of privilege and pain, neither of them entirely the result of my actions. "It's the richness of the mixture," moans Saul Bellow's hero in *Henderson the Rain King*. Nevertheless, this mixture is mine, my life; I recognize it and feel profound gratitude for it, for all of it.

One of the important truths about love that I have learned over a lifetime is that everyone one loves must be loved at a particular proximity or distance. Some, a very few, can be loved at a very close proximity. But mistakes are made, and sometimes the proximity must be adjusted. I can now happily love my first husband because he is at the right distance. We are both remarried, and the extended family gets together for holidays and family birthdays. We enjoy each other on these occasions. Living with him was the wrong proximity, but curiously, now that we have let one another go, we are free to feel love for each other. But the process of coming to this acceptance from an intensely romantic relationship is very difficult and takes a long time.

I met my present husband when I went to Cambridge to accept a junior position at Harvard Divinity School. A friend of Owen's, a teacher of mine, recommended that he "look me up." He did not know that my future husband was, at the time, getting a divorce from his first wife. I was very impressed from the beginning that Owen recognized the difficulty of my work, namely, teaching seventeen centuries of Christian history for the first time. He often showed up at my door with books he thought would help as I desperately prepared lectures for the next day. This behavior was in stark contrast with that of my first two husbands, who were jealous of my work. Or he came to my apartment and we silently worked on our different projects together. This was, of course, not all that attracted me to him, but it was certainly a strong part of a feeling, new to me, that I could *both* be with someone *and* do my work. After my first marriages, I was no longer willing to place "romance" ahead of work. Owen understood and respected that.

When we married, Owen had three young adult children, and I had two. Today we have four sons and a daughter between the ages of fifty-two and fifty-five. One of the most important decisions we made early in our relationship was to keep our finances separate. We split household expenses at the end of every month, but other than that our financial deci-

sions do not affect each other. This was important because we have both had adult children that needed financial help at various times. No matter what either of us might think about the wisdom of giving this help, the other's decision did not affect us financially.

HS: Now I am very unlike the typical Japanese wife or any conventional wife anywhere. Japanese housewives, when they find out I take my own business trips (often with male colleagues), ask me, "Does your husband approve of that?" Or they ask, "Who cooks for him?" I answer simply that he's quite a good cook if he tries, that there are many Japanese restaurants and supermarkets around, and that he's doing fine. I don't know how to respond to a woman friend who says, "Yes I'd like to go out with you but I don't know if my husband will let me." Or we might be enjoying talking together and she suddenly says, "I have to go now, to start cooking for my husband." I always wonder why they have to do that.

A Japanese friend, on her sixtieth birthday, declared that she was now going to retire from her role as eager-to-please traditional wife. She said that she wanted to be free to enjoy her life, travel with friends, go to shows, without worrying about the household. Her husband recognized that her choice was fair and accepted it. They still do things together, but the freedom created by her autonomy allows both to have more vivid lives.

When I was younger some nosy friends asked me, "Hiroko, you've been traveling so much, do you have a boyfriend on the side?" My mother-in-law asked, "Why can't you be a more traditional wife? Can't you be more considerate of my son?" That really bothered me, because my husband was giving me my space, as I gave him his. I just wanted to shout at her, "LEAVE ME ALONE, it's my life!"

MM: This conversation about relationship reveals a very interesting difference in our cultures. Psychoanalysis has had a major influence on American culture; it has trickled down into ordinary social life in the conviction that it is *always* better to address disagreements and differences directly, to articulate them, talk about them, even fight about them. Hearing you describe the reticence of your marriage, the way you gently worked *around* your needs and his needs when they differed, makes me recognize that confrontation is not necessarily the best, or the only, way to resolve differences.

4

Children

MM: How did you have four children in five years and manage to emerge with energy for doing other things? Three of them must have been in diapers at any moment!

HS: I like children but yes, four in five years was a bit much. But at the same time that I was taking care of them I was trying to find what I really wanted in my life.

When I found out that I was pregnant for the fourth time, I looked up at the sky and asked, "Again?" A very short time had passed between the birth of the third one and the fourth. At that time, the oldest was four, the second two and a half, the third one not yet two years old. When I was seven months pregnant with my youngest, I needed to go somewhere on the train. I had to transfer at a crowded train station, so I carried the second child on my left arm, the third one on my right arm, and I told the oldest to hold my flared skirt so that we could stay together and push our way through the crowd. Actually, that trip remains one of my favorite self-images.

However, it was never-ending labor in those days, requiring twenty-four hour attention every day, but I enjoyed immensely being surrounded by little ones. I feel myself fortunate to have four children. And they are still very close to each other. But at the same time that I was taking care of them I was trying to find what I really wanted in my life.

Part I: From There

MM: So bringing up children gave you a sort of time-out in which to think about your own future. You used the time when you couldn't do anything but care for children to build energy for the next thing. You were not just waiting; you were planning and thinking.

HS: Yes, and I was also developing some skills that were very useful later. It is difficult to raise children *and* find time to write, read, or work, so I learned to multitask. I could not use babysitters because it was difficult to find one, and no family members lived close enough to babysit. I learned to watch the children and make sure they were okay *while* I was working; that is a skill that women acquire. I was forced to learn because I didn't have time to focus on only one thing at a time. And that skill serves me well to this day. Multitasking works equally for small tasks or big projects; whether I am taking care of children, entertaining guests, or producing exhibitions, it's impossible to do only one thing at a time. Nevertheless, when the children were little I sometimes got very frustrated with not having the freedom to do what I wanted.

MM: Usually it has been women who know how to multitask, but now I sometimes see younger men developing the ability to care for children at the same time that they are working.

HS: I really wanted to return to school and I had the opportunity when my husband got a grant to go to San Diego, California. I immediately applied to graduate school. So I managed the children, took master's level courses, and taught at the same time. It was the busiest time in my life, but it was also a happy time. Because of the years in which I was frustrated with childcare, I wanted to be a part of the world again! I was strongly motivated and I was determined, so I had the energy. I was thirty-three when my husband had to go back to Tokyo because his leave from the university was over. I told him that I wanted to stay in San Diego with my four children.

MM: That must have been a dramatic moment for you; it wasn't the "done thing" for a married Japanese woman to take initiative like that.

Children

HS: It was the first time I strongly said what I wanted for myself, which was so different from what my husband wanted. Yet he didn't say no. On the contrary, he encouraged me and promised to support me. So the children and I stayed in San Diego. The children missed him, but we had fun with the help and support of our friends and neighbors. One night we were invited to a friend's home and on our way home, all the children fell asleep in our big station wagon. When we got home, I carried the children to their beds and I went to sleep. In the middle of the night I heard the doorbell. I waited a few minutes to see if I heard right, but it didn't ring again, so I went back to sleep. Day was dawning when I heard the doorbell again. I went to the door and found my five-year-old boy standing outside. I opened the door asking, "Why are you there?" He said, "Mommy, you left me in the car." I hugged him tight, telling him how proud I was of him that he did not panic and stayed in the car in the garage until morning. After this incident, the children themselves made sure they were all accounted for, counting 1, 2, 3, 4.

I think it was good for the children to live abroad when they were young, although naturally they struggled a little to adjust when we ultimately returned to Tokyo. A strategy that I found useful when my children were growing up was to let my friends take care of them, while I took care of theirs! Other people's children listened to me! It worked. So I did my best to look out for our neighbor's children, and encouraged them to look out for mine too. We had friends coming to our home all the time, so all the neighborhood children were exposed to different kinds of people. In those days I was not as busy as I was later, so I didn't mind cooking for them. Often they didn't leave, so when I was tired I just went to bed and they slept there and waited for the first train in the morning. There was no privacy, but it was good for the children to learn that people are different, that they have different backgrounds and perspectives.

MM: Like you, I got very bored in the years when I was at home with children. I read a lot, but I felt terrible sitting on the edge of the sandbox while they were playing. I felt that I was never going to get away from this, that I would always be sitting on the edge of some sandbox. You don't have perspective when your world is framed by children's needs. You're usually tired because you don't sleep well when they are infants, and it's hard to maintain perspective. I thought that my life was being sacrificed for their

Part I: From There

lives. And I thought that they should be grateful. Years later I realized that many parents suffer over children's ingratitude even though the children never asked them to sacrifice for them "night and day," as my parents claimed they did. Similarly, they suffer over their children's choices when they don't really know what these choices will lead to.

> "Pain is often thrust upon us in this life, but suffering is voluntary."
> ~ Susan Trott

That pain and suffering are not necessarily synonymous has been a useful insight for me. Many, many times I have asked myself if the suffering I feel is necessary. Of course, some things *are* worth suffering over, and suffering should be saved for these things—the pain or death of loved ones, for example. Actually, the choice of consenting to suffering—or not—may be quite rare, a prerogative of the privileged.

HS: When my children were little I tried to do everything I could think of to keep my life interesting. I baked the family's bread. I knitted. I made the children's clothes. I wove baskets. I tried many things that I thought I could enjoy. But I always knew that something was lacking in my life. I didn't know exactly what it was; I just wanted to be part of the world. I was aware that I was missing a great deal that was going on. I felt isolated. I was the same age as my husband, but he was building his career while I was only with the children. I had thought that I would be content just being a good wife and a good mother, but the reality was different. And I am not a good housewife at all; when we had guests I cleaned, but I didn't like the everyday routine of cleaning the house.

MM: Because it's not interesting! It only has to be done again.

HS: One year, when all four of my children were in elementary school, the annual field day occurred. If you have one or two children, you go either in the morning or the afternoon, but I was there all day, dutifully cheering, shouting hurrah, hurrah! At that time our third child was recovering from an illness where the circulation to his joints was compromised. He had to wear a brace on his leg, but on sports days he ran anyway. Years later people remembered the little boy running in spite of his leg brace.

It took about four years for the bones to get strong, but now he is fine. I still have his last brace. Now he's a designer, at least partly because of that leg brace and the intricacies of its design, I think. He was a sensitive child and recently, as a young adult, he suffered from depression for awhile. I desperately wanted him to overcome it, but even on days when he was not sociable at all I accepted him as he was. I did, however, hint that he should understand depression as a symptom of a disease, a chemical imbalance (this understanding of depression is not widely accepted in Japan), and suggested that he talk to a doctor. I have found the ayurvedic approach to holistic health helpful for myself. I wonder if it might help him too but I won't force anything on him.

MM: I can see that would probably be counterproductive. I have found that I need to accept that mothers are irreducibly "heavy" to their children. This means that the grown child's instant reaction is to resist our advice, or even, sometimes, our presence. For years I felt hurt that my daughter chose to marry in a courthouse without my presence. She thought it was nobody's business but theirs. Though I promised I wouldn't cry, she said that my presence would make the event "too heavy." Well, there's an example of voluntary suffering! I thought that a marriage that couldn't be "heavy" had very little chance of survival, but my daughter and her husband have been married twenty-six years and counting!

What kept you going during the years when your children were growing up? What were your pleasures? Many women never recover from that time-out from the public world; the exhaustion, the lack of nourishment for the mind: these can sap one's energy permanently. It took me awhile to get over those early years and I only had two children. So I admire you and wonder how you managed to emerge from those years with energy. Did you have friends who helped?

HS: Yes, I had friends who also had children and we got together. I had two friends who were pregnant at the same time I was. It was very helpful to have friends that were sharing the experience. Much later one of my friends from those days took our combined children—six of them—camping by herself. She was a tiny person but she had so much energy. With the help of such friends I was able to survive.

Part I: From There

MM: I agree. Women friends who know what you are going through are an enormous help. You feel a solidarity, a community.

HS: Yes, that was a real community.

MM: It's not usually possible for young parents in the United States to have extended families. Because people move so much, the young family is not likely even to live near their relatives. But children need more attention and affection than the parents alone can provide. When their children are infants, the parents don't sleep well; they are also working, trying to make a place in the world, so they're preoccupied and there's just not enough time and energy to give to the children. And in the United States there are many one-parent households in which the stress on the single parent is even greater. When related extended families are impossible, however, it is important to create intentional extended families among friends who are committed to each other.

I'm wondering whether the quality of your friendships with women has changed from when you were a young woman. I ask because my friendships with women have changed very much. When I was a young woman I went shopping with my friends. Or maybe we'd go to a movie together when our husbands were studying. But I didn't talk with them about problems or anything to do with my husband. I thought that would be disloyal. So my women friends were not in any sense intimate. Gradually throughout life, however, I have opened myself more and more to my friends. I have also come to rely on them more and more.

> "We do share each other's experiences when we suffer with others from seeing their pain and feel happy and relaxed [with others] and are naturally drawn to love them: for without a sharing of experience there could not be love."
> ~ PLOTINUS

HS: Friends sense when something is troubling us or when the other person is very happy. Having dinner or a drink together, a relaxed moment in the midst of ordinary life, that's all you need in order to intuit the other person's life. You don't have to be inquisitive about the other person's life. You simply enjoy the moment together. That is a joy. Old friends are

the best, friends that have been through various circumstances together. I have those kinds of friends.

MM: Like friends, music is, and has been, very important in my life. My father required me to play the violin with my stubby little fingers when I was four. And as long as I remained in his house I had to continue playing the violin. I hated it. But when I left home, I missed music, though I did not miss the violin! Then I played classical guitar, vihuela (a sixteenth-century ancestor of the guitar), and a Renaissance lute.

Much later during graduate school I accompanied a baroque tenor and a baroque soprano and I played in a restaurant. I didn't like to perform because I had such terrible memories of childhood violin recitals. I had "performance anxiety"—the real kind! But if I were accompanying a singer I could imagine that no one was listening to me. Or when I played in a restaurant, *really* no one was listening to me! I was background music!

When I got the position at Harvard, it was so demanding that I didn't have the three hours a day necessary for practicing the lute. It's a very difficult instrument. So I stopped performing, and now I have had to stop playing even for my own pleasure because I have arthritis in my hands. Now I love listening to music.

> "When music was difficult to find it was very powerful."
> ~ ADAM PHILLIPS

HS: Speaking of relationships between mothers and children, I was not what might be considered an "education-minded mother" when my children were in school. I didn't force them to learn anything, but I wanted to create an environment where they would learn whenever they were ready. I didn't send them to cram schools for test preparation unless they wanted to go. I was not good at helping with homework or checking in the morning if they had everything ready for school. That was another result of having four children in five years. Instead, I let them be responsible for their own business. Maybe I was simply a lazy mother in that sense!

Once children reach adolescence and become teenagers, their relationship with their parents changes dramatically. They don't listen to their parents. But I have always been close to my children, even now when we see each other rarely.

Part I: From There

When my daughter was twenty-four and a doctoral student at Columbia University in New York, I visited her at the end of the first year in the program. I was confident she would do quality work and get her PhD, but I found her very thin, lacking confidence, and crying over how she couldn't write her next paper. When she told me about problems in her department and the enormous stress she was under, it reminded me of an incident when she was three.

She was a very active little girl and we lived in a two-story house. She had no problem going up and down the stairs, but one day at the top of the stairs she just began crying: *Mommy, I can't go down*. And I was shouting from the first floor, *Why not? You do it all the time*. But she was stuck, saying, *Can't, can't, can't*, until eventually I persuaded her.

I recognized that little girl was the same girl that was at Columbia University. It was one of those moments when you have to show that you are still willing to be a parent, and I was glad for the opportunity. So I just went to her and hugged her: I hugged her through the night. And somehow after that, with her boyfriend's support, she was able to finish the first year of her doctoral program. Then she decided to take a year off, but she didn't come back to Japan; she found part-time jobs at museums and galleries. Then she was able to go back to her studies.

MM: It's important to tell that story. My daughter had a similar experience with her daughter. My granddaughter was twenty-four and in a doctoral program at UCLA when she had a similar meltdown. She was doing very well in the program, but also had some disappointing and difficult life circumstances. She called her mother, crying and crying, unable to stop crying. So my daughter dropped everything and went to Los Angeles to be with her for a week. She cleaned her apartment; they shopped, slept, and ate, and she succeeded in cheering her up so that she could go on.

I have heard of other young people, deeply invested in difficult studies or careers who need "times out," some love and reassurance, and even permission to regress briefly to childhood. When this is given to them, they are able to get up and go on. Parents become frightened when an adult child has a breakdown. "Tough love," preached by Alcoholics Anonymous and Al-Anon, has filtered into American culture. And we read in advice columns in newspapers and magazines that we must be stern, set boundaries, and in no way "reward that behavior." It seems to me that that is, traditionally at least, the "father's way"; mothers' instinct is

to be a parent again (briefly), trusting that the child, fortified by love and attention, will be able to get on with her life.

The high rate of suicide among teenagers and young adults may be one result of our preference, as a society, for tough love. If parents do not provide a reprieve from the demands of the young person's chosen life, her/his panic and inability to go forward can harden into a major trauma. Of course, it is never obvious whether it is tough love, or a brief retreat, that is ultimately beneficial. One response does not fit all sufferers, but I do think that Americans' preoccupation with tough love should be questioned and other alternatives considered.

You have talked a bit about your adult relationship with your daughter. My daughter, now fifty-five, is my best friend. We are only eighteen years apart in age, which, *to me* anyway, doesn't feel like much. We meet for lunch and play Scrabble. She always wins, at least partly because I find it impossible to keep my attention on the game; for me the fun is talking with her, the game is just an excuse to sit and reflect on this and that with her. She is a wonderful mother, a successful businesswoman, and an intellectually curious reader.

Perhaps we should also talk about mother-son relationships. My relationship with my adult son has been a demanding part of my life for the last thirty years.

> "The questions are not, What did I do wrong, and what should I have done differently? They are, Why did he persist in things that didn't work and why would he not go for help or accept it when it was offered? These questions are unanswerable, of course, but then so were the original ones."
> ~ Sue Chance

At the same time that I finished graduate school and began teaching as a junior professor at Harvard, my son finished college. He did not graduate; his basketball scholarship expired, but although he had attended for four years, he had not completed the general education requirements. I began to notice that he had no goals, other than the next high, and that he was not seeking a job.

During this time I was on the East Coast and he was on the West Coast. I was working hard and under a great deal of pressure in those first

years of my career. Not able to see him at close range, I felt I had no option but to ignore what he was—or wasn't—doing; I knew, and didn't know.

I was used to trusting my children to make choices, and my daughter had done well with this policy. My son didn't. He has had substance abuse problems, mainly alcohol, for over thirty years. How can I tell my story of thirty years of helplessness, anguished incomprehension, and increasing grief? And, of course, it must be *my* story; I cannot tell his story, which would be quite different than mine.

I attempted to help. In the first decade I paid for three month-long detoxification and rehabilitation programs. He was willing to take a vacation from his life for these periods because living on the street in Los Angeles was no fun. But the treatment programs were *my* idea, not his. So of course they didn't work. In 1993 he wrote me a letter saying that he suffered from depression and that alcohol and street drugs were/are his way of medicating. I consulted with a psychologist friend and found a psychotherapist in his vicinity. Some time later, the therapist called me to say that he thought I should know that most of what I was paying for was missed appointments. So that was that.

I tried to find an Al-Anon group that would help me, but was dismayed by people boasting of withholding support from their alcoholic family members in what I thought were very cruel ways. I was tempted to throw my life away in agony over my son. What right did I have to be happy and productive when my son was suffering? So in the early 1990s I had about a year of psychotherapy with a therapist who specialized in working with families of alcoholics. I realized that focusing on his life would help neither him nor me. So I determined to figure out what amount of money I could give him, and then refuse to give more. This freed my mind and enabled me to teach and write in the intensive way I needed to if I were to achieve tenure at Harvard. I needed to be able to *think* well. I did get tenure; in 1985 I was the first woman tenured in my Harvard graduate school. And, over the years, I have written sixteen books. But each achievement has had a bitter by-taste that I couldn't ignore, a sick feeling that the achievement was hollow because of failing with my son.

One of the primary foci of my work with the therapist was the need to sort real guilt from false guilt. There was some of both: my divorce from his father greatly affected my son. Although divorce was common among his friend's parents, he felt our divorce as the termination of his world.

He was bitter and hostile. I misinterpreted his behavior in a way that, in retrospect, I see as self-serving. But at the time I had no conceptual alternative for thinking of his behavior as anything but that of a "naughty boy." I did not get him professional help. I was distracted by my education and second marriage, annoyed by him, and not interpreting his behavior as evidence of suffering.

This is grounds for real guilt. False guilt emerges from ignoring the fact that I was not the only influence or the only person responsible for him. I was awarded custody of my children in the divorce settlement, but I allowed my son to return to his father and the house I couldn't afford so that he could continue to play basketball with his teammates. He was adamant about wanting this, and I was worried about my ability to handle him. He did not obey, and at the age of ten he was physically stronger than me.

Did I do the best I could under the circumstances? Probably, but "the best I could" was not enough. The Greek chorus says:

> "I know you've suffered much, but in this you are not so unique."
> ~ BOB DYLAN

The story is much longer, and more complex. Nothing worked, but I did not want him to die. In 1994 his father and stepmother, together with my husband and I, went with him to a therapist who helped us determine what we could manage. At that meeting it was decided that I would pay him a social security income so that he would have a base—food and shelter—from which to find a job. This was partially to benefit me: I could not do the very demanding intellectual work that was required by teaching at Harvard if my son was on the street. So I sent him money for groceries and rent for the next fourteen years. Soon I had to pay his rent directly because he wasn't paying it; I still sent him money for groceries. Finally I had to acknowledge that most, or almost all, of the money I sent was buying beer. And he was going from bad to worse. On one occasion he had a psychotic breakdown in which he imagined that people were trying to force their way into his trailer. He was screaming and throwing things out of his trailer until neighbors called the police and he was taken to a psychiatric ward for several days. This episode frightened him and he declared himself committed to stopping drinking. It didn't last long.

Part I: From There

Fourteen years after our visit to the therapist, his father and I acknowledged that sending him money for "groceries" was not working. In order to minimize his temptation to buy beer instead of groceries, I agreed to drive to his home/trailer every other week to buy him groceries. He was to have only ten dollars a week for spending money. This worked for awhile, although at significant emotional and physical expense for me. And he drank whenever friends brought beer. Then, quite suddenly, this year he took initiative to acquire a social security income. This occurred the same week that my financial adviser informed me that I was spending my retirement funds too rapidly. At the same time, I realized that I was thoroughly tired of taking care of his financial needs and could quite calmly and confidently say, "Enough, no matter what happens, I am not doing this anymore."

I do not know how to think of my son. Often I think of him as utterly alone, lonely, and longing for me to be his tender, sympathetic mother. At other times I think that I have represented all that is most dangerous for him—dependence, sympathy, and love that does not require him to grow up, to become self-sufficient, even to *give back* a little.

Yet he is a good person. He is a good friend to his friends, several of whom have been friends since the fourth grade, men who now have children in college, homes, and good jobs. He is generous, and loves his family. His drinking has seldom disrupted family occasions.

Many of my women friends also have problem sons. I have tried to analyze this as a social, not an individual problem. As a feminist, I am reluctant to say what I think I see, which is that a generation of now middle-aged men grew up expecting that a woman would care for them, financially and emotionally, and would manage the household and children. But in their early adulthood, the feminist movement occurred, and young women became too smart to sign up for this scenario. As I understand it, my son's idea of relationship can be described in the following lyrics:

> "Up on Cripple Creek she sends me,
> If I spring a leak she mends me,
> I don't have to speak, she defends me;
> A drunkard's dream if I ever did see one."
>
> ~ The Band

My son's paternal grandparents' relationship exemplified the model: his grandmother cooked, cleaned, worked outside the home, and supported his grandfather, a drunk all the time my son knew him. But times have changed, and my son has not found his caregiver. As we discussed earlier, most men adjusted their expectations of women. He did not.

Again, it's a question of distance. Parents and adult children must negotiate the distance at which they can love each other. Certainly, financial and emotional dependence do not create the right distance. Both sides feel frustration, irritation, and anger in the relationship.

Part II
STRATEGIES

5

Images and Models

MM: My grandfather was a farmer in eastern Canada. I have a snapshot of myself taken when I was two and a half, sitting on a feed trough in his large chicken pen. I was terrified of the chickens because when I entered the pen with my grandpa, they all flew up clucking loudly and flinging feathers and dust in my face. One day Grandpa taught me to simply stand still and wait a few seconds until the chickens subsided and went about their business. Indeed, I saw that although they still fluttered up in my face, they soon settled down and resumed their pecking in the dust.

The snapshot was taken the day I learned to wait for them to settle. I remember feeling very proud of myself as I sat among them. That image and the feeling it evoked has been very useful to me. Before I gave my interview lecture at Harvard, I feared that in the discussion period after the lecture, the very intelligent and knowledgeable people there would attack my argument. So I determined that I would breathe calmly until the questioners subsided. Indeed, there was a flurry of questions, but since I was not frightened, I was able to answer thoughtfully. This was my first job interview, and I got the job.

HS: What a great story! It reminds me of an episode when I was ten years old. In a music class one day, pupils were taking turns singing one note of the scale. When it was my turn I sang "la," and my la came spontaneously and carried well. I surprised myself. It felt great! I still remember

so vividly where I was sitting in the classroom when the la came out of my throat. It encouraged me to become a member of the school chorus, a rather prestigious choir that always won first prize in choral competitions. I had no musical training, as most members of the choir did, but I sang soprano and enjoyed it greatly. It was one of my first experiences of spontaneity and serendipity.

I was chosen to participate in a famous national children's singing contest. When it came to my prefecture, Yamaguchi, it was held in the largest hall in the town. My parents were so proud! My father told everyone, "My daughter will be the third to sing. Don't miss it!" He had no doubt that I would be one of the best. But alas! I did poorly, partly because my music teacher had required me to change my song only two days before, so I did not have enough practice. My poor father! I felt so sorry for him. The girl who sang after me won first prize, and she went on to become an opera singer in Italy!

My early models were the Spanish Catholic nuns I lived with during my freshman year at boarding school. They came all that way to educate Japanese high school girls, trying to create the best educational environment possible. Their efforts, passion, and devotion to us were tremendous. They were strict, but sometimes they were so playful. I especially admired the headmistress, who was very intelligent and had an irresistible aura. She was very different from my teachers in elementary school and junior high. She saw the school she established grow into a solid operation, and once the system was running smoothly she decided to go to a remote area in the Philippines, a place with no public transportation that takes a full two days to get to from the nearest town.

When I was in my late twenties I found another role model. She was an author who left her husband in Japan and went to Spain with her young daughters to study. Her example gave me strength later, when I decided to stay in the United States while my husband returned to Tokyo.

MM: Because women are inhabiting new roles, there may not be a single model who has the combination of skills and attributes we need; we may need to put together several models.

HS: Yes, I put together several models, one of whom helped me through one of my worst years, though he didn't know it. In 2004, I had

Images and Models

to close my former company. The whole year leading up to that had been like going from heaven to hell; in January my mentor died, in April my business partner died, in May I had to undergo major surgery; and then I realized that I had to close the company. At that point Matthew became my inspiration.

Matthew Carter is one of the world's foremost typeface designers. Some of his more well-known fonts include Bell Centennial, Georgia, Tahoma, and Verdana. I met him when I was a volunteer interpreter at the 1988 International Graphic Designers Conference in Tokyo, and I've had the pleasure of working with him on a number of projects. He has lived through three generations of typeface design, from hand-carving, to phototypesetting, to computers. He started by working alone creating typefaces by hand. Then with phototype he learned to work with a factory. When computer design appeared he mastered that too. He was the vice president of a font foundry and graphics company for ten years, but because of all the administration the work required, he only managed to design one typeface during all that time. He became frustrated knowing that what he did best was designing, so together with Cherie Cone he started his own studio. With the technological advances, all that was needed to develop a new typeface was a computer, good software, and a printer. He became far more creative and much happier.

Although our fields were different, he inspired me to do a similar thing. I closed my company and started a new company with one assistant. I invented a new work style, which gave me more freedom, both creatively and financially. It has been working very well. Rather than maintaining a large company, I put together a team of the experts as needed for a particular project. Thanks to my laptop and mobile phone I can communicate with my clients from anywhere in the world.

When it comes to producing cultural events, almost everything I know I learned from a man named Ikko Tanaka. Ikko was probably the greatest Japanese graphic designer of the twentieth century and his work is known and respected around the world. We worked together for the last fifteen years of his life. He taught me everything, from the essentials of organizing exhibitions, to how to interact with people, to how to build team spirit, and he showed me that producing a project could be a lot of fun.

I happened to sit beside him at a dinner at the 1988 conference of graphic designers in Tokyo at which I met Matthew. It was difficult to

Part II: Strategies

become a member of that prestigious organization, and Ikko was one. As his work became more international, I helped him as an interpreter and coordinator. From then until his death I was always with him on international projects, including retrospectives of his work shown in Mexico City, Milan, New York, Sao Paulo, and Hangzhou.

Aside from producing exhibitions of his own work, he arranged shows for other international design figures, including the shoemaker and brand founder Salvatore Ferragamo. It was a huge project, starting in Milan and traveling to Tokyo. Through assisting him, I learned the full range of tasks involved in an exhibition. I took the skills I had learned and went on to produce a range of events on subjects such as Audrey Hepburn, Chinese ceramics, historic Japanese woodblock prints, modern Italian photography, and contemporary Finnish art, to name a few. I don't have any particular field of focus when it comes to exhibitions. Whenever something interests me, I work directly with the curators and museums to make an exhibition happen.

Wherever we were, he always made time to enjoy the moment and the place; he shared that with everyone around him. One of his lessons was that when one gives a gift it should be the very best, specific to the person, occasion, and the best that one can afford. Similarly a restaurant meal should be thought of as honoring the invited friend. I value this approach for business as well as personal relationships.

Through Ikko I met Lou Dorfsman, a graphic designer, art director, and type designer in New York. Lou's work as an art director is well known in the industry, but what most impressed me about Lou was his charm. His way of interacting with people made everyone around him feel cheerful and cared for. And he told hilarious jokes. Whenever I was near him I felt that the world was wonderful. I worked with Lou on some of his lectures and coordinated his trips to Tokyo. It was a minor involvement but I had many chances to see him and he had a great effect on me. He was fully established in his field but he showed no arrogance and he never manipulated people. Once when I was in New York just before Christmas, Manhattan was covered in decorations and the city was full of festivities. After a great lunch with Lou, I actually sang on the way back from his office to my hotel.

Lou was Ikko's *sensei*, or teacher. Ikko, Lou, and I had great times together; because of Lou I met David Levy, who at that time was the dean

Images and Models

of Parson's School of Design in New York. David contributed greatly to building a globally recognized design school. I later helped set up its affiliated institute in Japan. These people gave me extraordinary encouragement and endorsement. I was not a designer; I had no art or design background, and no credentials, but Ikko and Lou and David trusted me and gave me opportunities and support whenever I needed them. Thanks to Lou's recommendation, I became an adviser to the International Design Conference in Aspen. It was one of the world's most important design events. Subsequently we created a Japanese version, which ran for seven years. I was looking for a great project that I could be part of and those people gave me that opportunity. They introduced me to the world of design.

MM: That is a remarkable story. You had no training in the field of design, but they recognized that you had the eye and they gave you the rest of what you needed—a network of top designers in the world.

HS: I have other inspirations as well. I have a friend who is an artist in Sao Paulo. Her husband died when she was forty and she started her career as a painter while raising her two sons to be happy and productive adults. Now she is ninety-three and still very active. Recently when someone tried to commission a painting, she said maybe. When she was asked to make a sculpture, she said yes, but when she was recently asked to make a large piece of outdoor public art, she said *Yes, yes, yes*, with a big smile. She readily accepted a completely new challenge at the age of ninety-three! Isn't it amazing?

I also know a ninety-year-old Italian woman who is very elegant. During World War II, she was in Switzerland, carrying a handbag she had designed. It was so admired that she decided to become a handbag designer. We met when I organized an exhibition of her innovative handbags. Together with my team, I spent a week with her in Venice, trying to choose which handbags to exhibit. She was full of energy and so excited about the exhibition, but at 5:00 in the evening she said, *Let's call it a day. That's enough for me*. So she had a Campari and sent us off to dinner, saying that she had made a reservation for us at one of her favorite restaurants, and that she needed her rest.

Part II: Strategies

MM: We are so dependent on inspiration from people who love what they do, and do it with their whole heart and mind.

HS: Absolutely, Margaret, even if I am having a hard time, I think of one of those people and it gives me the strength to keep moving.

MM: It is also important to know that there are people who work well even when they lack youth, health or other advantages. You have to *see* this, not just know it abstractly, in order to be able to learn from it. There is so much courage in many ordinary people's lives.

HS: Yes, they don't have to be famous people.

MM: We need them, and I like to think that we also help them by *seeing* them, by recognizing their courage. People of courage are all around us but we seldom see them; they are seldom encouraged by anyone's acknowledgment. Even if we don't say anything, I think that they recognize our acknowledgment.

HS: Another friend, the director of a museum in Florence had her first baby at the age of fifty. She wanted a baby so badly. People told her that it was impossible to have a baby at the age of fifty, but she thought differently.

MM: You've told me about some inspiring men in your profession; do you know of inspiring women who are in your profession?

HS: I've made many great women friends who also have their own careers, often in art-related fields, and it's so much fun to work with them. In 1997 I began a very big project with some Finnish organizations. Our exhibition focused on city planning and featured cultural events and performances. We organized twenty-three venues in Japan, from Hokkaido to Kyushu. The event continued until 2000, which coincided with Helsinki's 450th anniversary and its award of being named European Capital of Culture. We brought festivals, cultural events, exhibitions, and seminars from Japan to Helsinki, celebrating the fantastic exchange between the two countries. All the major organizers of those events were women, and

the camaraderie, and our celebrations and sense of bonding, were wonderful. I still maintain those relationships.

An amazing woman whom I think of as a role model retired after a career directing several museums. Because she is now free of management and budget concerns, she is happy to remain very active in the art scene. I learned a great deal from her; she has a great sense of humor, curiosity and creativity, and is independent, smart, and talented as well as being charming and inspirational. I visited her two years ago. She and a longtime artist friend bought a small schoolhouse in the country. It was close to a lake and had one hundred-year-old sauna. She spends every weekend there. We had a great time together one summer day, going back and forth between the sauna and the lake. We were like fish. The memory still makes me smile.

I would say the same about you, Margaret. Before I visited your home in October 2007, I had no idea what kind of person you were. I was a little daunted: you had been a professor at Harvard and the academic Dean of the Graduate Theological Union, Berkeley, so I expected somebody very "establishment." But you welcomed us and served tea and cookies and I thought, what a beautiful person, speaking so softly, so full of intelligence, thoughtfulness and inspiration, and offering us such hospitality. I could see you also had great fashion sense because what you wore fit perfectly. You contradicted my image of you! I felt so happy when you agreed to write an essay for the Buddhist art catalogue, and I wanted to know more about you.

Yes, an effective model is usually not a heroine from movies or books, but someone known, or even glimpsed.

MM: Teachers can also play very important roles in shaping aspirations. But teachers were not particularly powerful for me, perhaps because I was in my late twenties by the time I went to college. Actually, what I learned was not to rely on teachers! All I needed in a course was a good bibliography that I could investigate on my own. I also learned that I did not need to like a teacher in order to learn from him. I learned a great deal from one teacher that I did not like at all. That was a very valuable lesson.

Finding a model within my profession has been difficult for me and for academic women of my generation because not many women older than ourselves have had academic careers. Those who did, often thought

they should behave and look like honorary men. They thought that in order to look serious to others, they must look plain and dour. So I had to splice together several models in order to have the encouragement I needed *both* to do serious academic work, and to enjoy dressing attractively.

Sometimes role models appear in unexpected guises. When my daughter was little and we were out somewhere eating an ice cream cone, she often got chocolate, her favorite flavor, all over her face. So I would lick a tissue and wipe her mouth and cheeks with it. She *hated* having that done to her, but I thought, okay, wait until you have a child and you will do the same. So I waited to see that day, and it came, but with a significant difference. My daughter held the tissue for *her daughter* to lick, and then wiped her daughter's face!

6

Habits

HS: Let's talk about the daily habits that sustain and support our professional endeavors. What are our strategies for keeping fit, managing stress, and eating?

MM: For me the most important habit is the habit of attentiveness. I call it a habit because it can be intentionally developed and exercised. There is so much around us that we don't notice at all.

> "Should we not...endeavor to see and attend to what surrounds and concerns us, because it is there and is interesting, beautiful, strange, worth experiencing, and because it demands (and needs) our attention, rather than living in a vague haze of private anxiety and fantasy?"
> ~ Iris Murdoch

The everyday world tries constantly to seize our attention, but we are usually inattentive. The following is a small example: when I was the academic dean of a graduate school, I found the work quite urgent and stressful because almost every decision made a difference in someone's life. I was not able to leave problems in the office; they often attacked my mind in the middle of the night. One day I noticed some bruises on my outer thighs and puzzled over how I got them. Finally I realized that I got

Part II: Strategies

them from bumping into my desk as I walked around it. My office was large, so it wasn't that the space was close. It was simply that I was moving at the wrong pace. I understood that if I paid attention to those bruises and consciously relaxed from my hurried pace, I would not need a car accident to get my attention!

At one point I made decisions about exercise and diet, but now they have become habits. I do not think each day, shall I exercise today? I just do it; it's part of the day. I exercise first thing in the morning. I get out of bed, wash my face, put on my exercise clothes, and go to the gym before my body wakes up enough to say no! I also have an exercise buddy; she does not urge or scold, but on mornings when I might rather sleep in, there's someone who notices if I'm there or not; it's enough to get me up. The companionship is very helpful.

HS: You "do it before your body wakes up enough to say no!" That in itself requires some discipline! For a short period of time I had a chance to stay at an apartment with a great spa in the same building, but I didn't go to the spa as much as I thought I'd like to because I listened to my body too much! After a long day of work, once I stepped into my room, I simply could not make myself go to the spa even though it was three floors below. When I listen to my body it tells me to go the lazier way.

MM: Sure, that's why you need to get up and go *before* your body says no! If I don't go first thing in the morning, I don't go all day because I cannot tear myself away from my work.

HS: Every other month I go to see an ayurvedic doctor. He checks my pulse in order to give me advice and, if needed, herbal medicine. I was glad to find a doctor I can trust since I greatly dislike having a medical checkup at a regular doctor's office. I am nervous until I receive my results. It feels to me like a school examination: either you pass, or you don't pass. And I hate being told by a doctor whether I am healthy or not, judged by scores and numbers. So I didn't have a physical exam for many years. Even after my major surgery several years ago, I went only once for a checkup afterwards. Also, I don't like to go to a doctor because something is wrong; instead, I want to work consciously to prevent illness.

The best health routine for me I believe is ayurvedic. A good friend introduced me to an ayurvedic clinic in the United States some fifteen years ago. I spent three days there and enjoyed it very much, but until three years ago I couldn't find a good clinic in Japan. My very simple rules are: I start my day with a cup of hot water; I eat only when I am hungry; I allow at least three hours between meals so that what I have eaten is fully digested; and I eat only one big meal a day. Every summer I have a three-week detoxification program for mind and body. My body is cleansed by diet and exercise; my mind is cleansed of its habitual thoughts by meditation. I am still a beginner; I began meditating only last summer. During meditation I try to drive away all my compulsive to-do lists. It is not easy yet, though.

One of the daily things I love is cooking. I love the whole process of thinking about what to cook and going to the market as well as the actual cooking. When I can't go to the market, I cook something that is in my refrigerator—improvisation, rather than a recipe, is even more fun. Cooking gives immediate gratification. So much of what we do requires the cultivation of a taste for delayed gratification, so it's good to have some activities that give instant gratification, that make daily life rich. I also love entertaining friends. In fact, I have learned a lot from entertaining that is transferable to producing an exhibition or a cultural event! It's the same thing, on a larger scale, as organizing a small dinner or party at home. All the things one must think of and the choices one must make are the same!

MM: One just needs a lot more help! How interesting! So the skills needed for producing an exhibition are simply an extension of the skills we learned from our mothers at home! We can be grateful to our mothers, then, for helping us develop those skills. It's important not to ignore or take for granted the foundations of the abilities we later develop and exercise. Although both of us have felt constricted by our socialization and have needed to resist it, it's important to notice also the ways in which we have benefited. Neither of us denounces our socialization as a whole, but rather we seek to identify the aspects that must be rejected or modified and those features of socialization that give us skills we can use. The feminist movement in the United States has tended to blame mothers for socializing their daughters to passivity and obedience. So mothers usually get a very bad feminist press, just as formerly they got a very bad psycho-

logical press. Feminists tend to consider grandmothers wonderful, on the other hand. It's really so shortsighted to ignore our mothers' gifts to us.

HS: We didn't want to be like our mothers, but they gave us a great deal to work with.

> "One should not attach too much significance to inner chat....
> Silence becomes the inner as well as the outer person."
> ~ Iris Murdoch

MM: Interior chat is one of our most intimate habits. What are the tapes you play in your mind when you need to calm and center yourself, to remind yourself of important things that you tend to forget?

HS: When something annoys me I always tell myself, stop thinking and worrying, go and have a sleep. Take a nice hot bath and sleep. You will be fine in the morning, or at least you will see things with fresh eyes. It works. I tell myself to stop thinking about tomorrow. One day is enough to worry about. I just concentrate on the present. Today's problem could dissolve tomorrow. There is always a solution, and finding a creative solution produces confidence.

When I am tired I want to be around people who are cheerful. What we call *kigen ga ii*—to feel healthy, cheerful—is so important, it's vital to do everything we can to project this. A good sense of humor always helps; a good laugh can bring cheer. At the family dinner table, for example, if one member is not *kigen ga ii* it brings everyone down.

Enjoying the present is a skill that must be learned. Every day I find tiny things that give me joy; I don't have to go to forests or deep into the mountains. I look at the sky; enjoy that moment, that light. Most of the time when we look around we can find joy and beauty. All we have is the present—always.

When I need to encourage myself on a dark day, or before appearing before a large audience, I take a moment to picture myself as a tree. I imagine that I am a tree in a vast field, standing dignified and firm. I am the only tree in the field but I am not afraid; I am alone but not lonely. In the summer my branches are fully extended, with thick green leaves

blowing softly in a cool breeze. In winter I bend over almost to the ground when heavy snow or strong rain hits but my branches do not break.

> "We must bend easily lest we break."
> ~ AUGUSTINE

I am firmly grounded so that no typhoon, hurricane, or tornado can uproot me. Whenever I see a big tree I like I greet it; if no one is around I give it a hug, or at least a warm touch, just as I give to my dear friends. Standing by a favorite tree I take a deep breath to get energy from it. I imagine that a great positive energy comes from the tree, penetrating and filling every cell of my body. I also think of other people as trees; I sniff them to see if he or she is my favorite kind of tree or not.

When I want to treat myself, I have a great massage. Or I go shopping. I always enjoy finding something innovative. Even when I am short of money, when I travel I find a good hotel, not something cheap that makes me feel miserable.

When I get sick, I consider that maybe this is the time for me to get sick. I hope that when I die, I feel that this is a great moment to die.

When I find something that interests me, I go for it. I don't worry about whether I have the formal qualifications.

MM: Or one can patiently, doggedly build the necessary qualifications in order to do what you love. Here are some of the things I frequently remind myself of:

When I am writing an article or a book, I remind myself to ask colleagues to read a draft and comment on it. It is amazing how I can forget things I know very well when I am working alone. That is one feature of teaching that I miss: exposing my ideas to students in order to solicit their perspectives and comments.

I frequently need to remind myself to breathe, to notice my breaths and to breathe more deeply and slowly. I also remind myself not to "carry" my shoulders; they will come along when I walk!

I have vowed to myself never (again) to be bored, and I have found tricks to ensure this. One of my tricks is to memorize poems I love so that, in a boring meeting, I can seem to be present and attentive when in fact I am saying in my mind a glorious poem like Wallace Stevens'

Part II: Strategies

"Sunday Morning," or T. S. Eliot's "Ash Wednesday." I love walking around with these (and many other poems) "by heart." They are insurance against boredom.

HS: We have been talking about our good habits, but we also have some that are not-so-good. For example, I'm terrible about being punctual. I am always a bit late. I've had many desperate moments because I want very much to be somewhere on time, yet it seems that the harder I try, the later I get.

I recently broke a habit I had for quite a few years. I used to check my mobile phone obsessively, even while I was walking or riding on a train or subway. I imagined that I might miss something if I didn't. I started to question why I always needed to be connected. Not many calls need to be answered immediately. So I stopped checking so frequently. What a relief!

MM: For me, eating is a sensitive gauge of my emotions. When my mother was dying, I suddenly lost appetite, losing twenty pounds in one month. At other times, I eat unhealthily—too much and too caloric. The combination of overwork and self-indulgence is particularly pernicious. I begin by having "treats" to compensate overwork ("I've worked so hard today, I *deserve*. . ."). Treats are wonderful; it's our daily eating habits that support, or fail to support, our health. But treats have a way of sneaking into habit, becoming no longer treats. I struggle to disengage my eating practices from my emotions; I would like to eat more rationally—the food, and the amount of food, that's good for me. Your ayurvedic practice, Hiroko, is a way to de-habituate—especially your once-a-year "retreats" when you cleanse your body by eating differently, and your mind by meditation.

At one time I worried that I was addicted to coffee. The way to determine if one is addicted to something is to give it up. If it is easy to give up, it's not an addiction, but if it's difficult or impossible, then it is. I suffered from headaches for a month after giving up coffee! Clearly, coffee had crossed the line between habit and addiction! After drinking no coffee for several months I decided that I would have coffee as a "treat"—a cup once a week. Unfortunately, coffee is also my writing drug; it really helps me to think and concentrate. So it sneaked back when I was writing my next book, and has been with me ever since.

The problem with habits, both good and bad, is that they deaden life. We give ourselves treats, but when the treats become habits, they lose their ability to give us pleasure. We begin to *need* them. Every now and then I need to de-habituate, even from good habits like daily exercise, perhaps finding different kinds of exercise than I routinely do.

Socrates said, "The unexamined life is not worth living." But sometimes I think I scrutinize my life, my practices and habits, too much. So then I remember a line from T. S. Eliot's "Ash Wednesday": "And I pray that I may forget / these matters that with myself / I too much discuss, too much explain." On a daily basis, I seek a balance between these two messages.

7

Critique and Self-Criticism

"People know what they do; they frequently know why they do what they do; but what they don't know is what what they do does."
~ Michel Foucault

MM: What does it mean to be self-critical? Because women have often been self-critical in a way that is destructive, we must clarify the difference between productive and destructive self-criticism. There is a kind of self-criticism that judges oneself harshly, repetitiously reinforcing our inability to challenge ourselves, try something new, or simply get something done. We import images, models, and goals from media culture that undermine our self-confidence. This kind of self-criticism needs to be corrected by endeavoring to stop seeing ourselves through others' eyes.

But there is also a valuable kind of self-criticism that is unlike being *critical* of oneself. Here language is a rough tool: the same word, "critical," can mean such different activities. The productive kind of self-criticism is an ability to stand at a little distance from myself, from my urgent emotions and projects, in order to evaluate whether my responses and methods are effective towards my chosen aims. Productive self-criticism prevents a person from doggedly continuing to use methods that fail to deliver one's goals. Productive self-criticism suggests other approaches or

styles that could be tried. Trusted friends can help with their observations, suggestions, and honest assessments.

For example, conversations with you, Hiroko, have helped me question the fruitfulness, in some situations, of my characteristic ways of working with myself and others. As I have mentioned, you have described to me styles of relationship—whether professional or personal—that work more by tacit adjustment than by confrontation. And you like to mix business and pleasure! These differences are partly cultural, partly professional, and partly personal responses to the circumstances of our particular lives, but they require constant scrutiny and adjustment.

Exploring our different challenges contributes to my toolbox of behaviors. It is fascinating to learn about your style, which is so effective in getting things done in the world—connecting people, recognizing business opportunities, figuring out what can be done and what it will take to do it. You put yourself at a different kind of risk than I do. In order to have an interesting and varied professional life, you sacrifice predictability and financial security. You trust yourself and your skills to lead you to the next project, the next opportunity that you can embrace with delight.

I, on the other hand, have needed the support of a university and a predictable income in order to risk in the realm of ideas. My training prepared me to think about texts, develop arguments, and generally help myself and others see differently. This is, of course, a rigorous discipline in itself; it requires a good deal of self-knowledge and toughness. It involves, with every publication, exposing myself to others' criticism. It requires me to evaluate that criticism and learn from it. When I read a review of one of my books, I must assess whether 1) the reviewer is simply saying that if he had written the book, he would have written it differently; 2) he is venting a certain personal resentment (perhaps resentment toward a woman from Harvard!); or 3) whether the review offers substantive correction of my ideas or writing style that I can learn from and incorporate in future writing projects.

> "If we want to know what we know, we must give up what we suppose about our individuality, our self, and our subject position."
> ~ ARNOLD DAVIDSON

Part II: Strategies

Soon after I began to work as a professional historian, I became bored with the insularity of the field. The professional conferences and colleagues in the field seemed limited as conversation partners. So I began to educate myself through intensive reading in other disciplines, most importantly, art history and gender and queer studies.

My second book, which worked with images as historical evidence, drew a lengthy negative review in the main journal of my profession from a retired art historian who resented the fact that I removed artworks from their pedestals and asked how public images communicated social and religious messages in particular communities. It was not, according to his best lights, the appropriate way to think about artworks. The review was devastating. I retired to bed for a day, cried a lot, and the next day I got up and resumed work. I accepted that if I continued to work in an interdisciplinary way, I risked such reviews, but, as I put it to myself, I am also determined to stay alive while I am alive, and that means taking risks in my field. Of course, I learned that they don't call them "disciplines" for nothing!

Gender and queer studies, in my estimation, have done more to make visible my culture and society's hidden assumptions about gender roles and expectations, heterosexuality, and the unequal and unjust distributions of wealth and privilege than any other academic discipline. Consider the assumption that heterosexuality is "natural," for example. If this is the case, why is heterosexuality so constantly and expensively reinforced in (almost) every billboard, television commercial and program, movie, and every other form of entertainment? Perhaps "entertainment" is not the innocent and playful mode of relaxation it purports to be, but a primary mode of instruction and reinforcement of cultural assumptions and values. Scholars, whose job is to examine and analyze past and present cultures, must be especially alert to excavating and critiquing our own assumptions and values as they inevitably pervade our work.

Productive self-criticism also involves not only the examination of our intentions, but also the attempt to predict the effects of the work we do. Aristotle's question, Where does it lead? is important for me to ask myself. For we do not act solely as individuals, but as members of a society and world. Ultimately, of course, the effects of any idea or activity are unpredictable, but we must bring an educated imagination to *trying* to predict possible effects. Whom, and what institutions, does our work

support? An indispensible part of the process of trying to predict possible effects is conversation with others, especially with the people who may bear the cost of the changes for which we work. There is no way to step into others' shoes and see through their eyes except attentive listening to what they tell us.

As an historian I can see that most people in the history of the West have thought only about their intentions. When I was in graduate school we read historical texts primarily, if not exclusively, trying to discern authors' intentions. We never considered effects, even in a hypothetical or admittedly speculative way. Sometimes, though, cumulative effects of certain ways of thinking can be identified, and it seems to me that historians should be good at suggesting what those effects could be.

But instead we shy away from seeing and saying anything of the sort. Here's one example: In the early fifth century there was a debate between St. Augustine and another Christian group, the Manichaeans. Augustine argued that human community, and therefore human responsibility, extends only to rational minds. The Manichaeans argued that the community of human responsibility consisted not only of rational minds, but also of living beings. Augustine, backed by the formidable power of the Christian Church and the Roman Empire, won. And the history of the West became the history of exploitation of the earth's resources that has brought us to the present ecological crisis. If the Manichaeans had won, we would perhaps have been more attentive to the welfare of all living beings.

To be fair, Augustine lived in a world in which natural resources seemed inexhaustible. But over centuries of ever increasing technological ability to damage the environment, his argument has encouraged exploitation of the earth. An effect on this scale cannot be documented; nor did Augustine *cause* it, but it should at least be suggested that ideas are dangerous, even an idea like Augustine's that *intended* only to urge attentiveness to human beings.

> "My point is not that everything is bad, but that everything is dangerous, which is not exactly the same as bad. If everything is dangerous, then we always have something to do."
> ~ MICHEL FOUCAULT

Part II: Strategies

HS: Critique is also important in design education. Students are taught to believe that they can always find a solution to a problem. So their presentations are critiqued, and they must learn to evaluate negative comments rather than taking them personally. Initially I was oversensitive and I got hurt and nervous when I was criticized, but getting older teaches one to accept criticism. We face criticism throughout life, so its essential that we find a way to handle it and learn the value of having others' perspectives on our work.

MM: I think we have to try to imagine a range of effects that could be produced by pursuing a particular goal—many of them unintended and some of them dangerous. For example, early feminists advocated overturning social arrangements so that women would be on top, men on the bottom. Is there a situation in which that might be the worst possible thing? What if women were ruling the world; we'd have a Margaret Thatcher here, somebody else there, and men subordinated just as women always have been.

The argument for women's equality, when it goes beyond a simple justice issue, is that societies need the *range* of human sensibilities, some that seem to be stronger in women than men, some that seem to be stronger in men. Both are needed. What we think of as men's strengths and women's strengths are due partly to socialization, but partly also to physical experience. For example, women who bear children are sensitized by this powerful experience to the fragility and value of human life. Eventually women and men need to learn to work together for the *common* good. All people are needed if we are going to make a difference in the world rather than simply creating another oppressive regime.

HS: I read an article about the changes in the Japanese workplace because of the presence of women. Some men find it difficult to work for a woman boss and when women working together go to restaurants and bars, men feel that they cannot participate. Women who have power tend to repeat the same dynamics as men did. Not so helpful.

MM: It seems to me so important to be thoughtful and self-critical about women's roles in society. For example, in exhibition venues in New York, Chicago, and Los Angeles, we had a wonderful time having lunches

or dinners with several of the women working with the exhibition. We loved to get away with only women. Ultimately, however, we must learn to do this with men too. But men must also change if this is to happen. Often they are such a drag! They take over the conversation! So many times I have been to universities where several faculty members take me out for dinner after my lecture. Very frequently, if there is one man in the group, he dominates the conversation. We let him! We must still assume (what Foucault calls "silently think") it's his right!

So it is not adequate simply to have women in the positions formerly held by men; we must also identify the most fruitful traditional styles of working and revise them to reflect women's values and skills as well as men's. We don't want to merely substitute old-girl networks for old-boy networks. I think that what we want is social arrangements that accommodate people working together with their particular abilities, skills, and interests.

HS: Possibilities for women are increasing. Hillary Clinton's campaign for the U.S. presidency made a huge difference in the possibilities women can entertain for themselves. Just by running, she raised the glass ceiling considerably.

MM: We don't know how to create something we've never seen. We have no experience of something genuinely new. We have to go along step-by-step, to keep noticing what is happening and on whose back this new thing is being built. Who is suffering? I don't care if men suffer a bit because they don't have total jurisdiction over everything any longer. But so many of the new things that have been built in the world over the ages have relied on slaves. The Greek and Roman civilizations we admire so much would not have worked for five minutes without slaves; yet everyone ignores slavery when we admire these civilizations. We don't want another civilization built on the backs of any kind of slaves.

HS: Do you think it's possible?

MM: Ha! That's a question we can't ask because we just have to try to do it. We may not see a huge change in our lifetime, but we can be a piece of the change.

Part II: Strategies

HS: A piece of the change: that's a good message to send.

MM: I've always been overly optimistic about what I can do. Then I get discouraged when it doesn't happen.

HS: I am similar. I am always making to-do lists, but at the end of the day I realize that there were too many things I should have accomplished, and I've only accomplished one-fifth of my list. But lately I've decided to see these lists differently, to say, "Look, at least you did this, this and this."

MM: I could have been more optimistic in my career if I had set my sights on smaller increments of change rather than on the final goal. For example, after being a faculty member for twenty years, and getting crankier and crankier about what I thought should be done, I took an administrative position as academic dean so that I would be able to *do* something rather than just complain. I had a list of things I wanted to do within the five years of my appointment. All of them had to be modified. Some of them didn't work out at all.

But when I look back and regret that I wasn't able to do the things on my list, and I look at the institution now, I see that, in fact, there is a professor of feminist studies and an Islamic studies professor, two of my agenda items. That didn't happen on my watch, but I was a *piece* of pushing for it. Others saw the conclusion. I have to feel good about being a piece of a process. Although I didn't get the credit for achieving the goal, I had the vision. I saw what was missing, and others took my efforts to the next step. Even when it is impossible to see what my efforts produce, I have to have a basic trust that it was not nothing!

Similarly, scholars often criticize authors who saw, and said with clarity, what should be done, but were unable to produce this behavior in their own lives. Perhaps they were womanizers, or sadomasochists, or they were slaveholders, to cite only a few of the possible criticisms. In short, the author's biography is often used to criticize his ideas. But the insight and skill necessary to have a vision and describe it in such a way that others are attracted to it is not necessarily the same as the ability to live one's vision. Authors who can articulate a vision so that other people can actually live out into it should be appreciated for their particular skill.

Of course, this is a little bit self-serving because I'm an articulator and I'm not always able to live as well as I articulate!

HS: So, articulating a vision and imagining possible effects is a method for being self-critical. This is also good advice for people who complain about the things they would like to do and think they can't do. They could begin by imagining an effect they would like to achieve and then strategizing about how that effect might be produced.

MM: There is a Buddhist concept that says that one should not be attached to a particular result of one's actions. Do everything possible toward that result, but then, surrender. Your part is to do the work; the actualization is ultimately not in your power.

HS: That's my strategy: do your best, and let heaven decide. The result you get may not be the one you expected or hoped for, but you may realize (and it may not be until years later) that it was very positive. That's what I tell my children.

MM: This is not a word that people like anymore, but there's a certain humility involved in acting without attachment to results, recognizing that I may not get credit for the work of which I am a part, that I may not even live to see the result in my lifetime, but still doing my part of the work with energy and commitment. There is a wonderful statement by an African American woman who lived to be a hundred, Anna Julia Cooper. She said: "It's not what you say that matters; it's not even what you do; it's what you *stand for* that matters." Of course, what you stand for determines what you say and do, but often standing for something is the most important thing you can do.

HS: You have to have courage in order to do that.

MM: And confidence.

HS: Standing for something you believe, delight in, and treasure is the richest life you can have.

Part II: Strategies

MM: Yes, the benefits come to you as well as to the world you hope to help.

HS: Can we give examples of when we have been self-critical?

MM: Here's one that comes to mind. My parents were fundamentalist Christians. It was easy enough for me to jettison those beliefs, but to my horror I began to notice that some of the assumptions of that worldview had crept into my scholarship. For example, the assumption that there is one right way to do scholarship, that there is one correct interpretation of a text or event. Totally divorced from religious beliefs, that assumption emerged in my scholarship. It took me years to identify that fundamentalist infrastructure in my own—and others'—scholarship. You mentioned that the same insistence on "one right way" appeared in your grammar school education in Japan.

In fact, when you think about traditional styles of scholarship, fundamentalist assumptions occur rather often in the field of historical studies. They appear in a scholar's attempts to claim the greater beauty and accuracy of his interpretation by belittling and/or "disproving" another scholar's interpretation. But there are many possible interpretations of any text or event, depending on the reader's perspective, her education, sensibilities, and sensitivities. No educated interpretations are wrong, and we need to hear them all when we discuss a text. That's why we have seminars for advanced students. The professor can't tell students the "right" interpretation.

HS: In design education, the method of learning is presentation and critique. Critique is not pointing out the weakness of the presentation, however. Critique is an art; it helps to articulate aspects of the presentation that the presenter herself may not even be aware of. It notices and points out connections within the presentation. It supports the presentation rather than demolishing it. A good critique analyzes in order to strengthen.

In Japan, there is a strong implicit prohibition against saying anything negative that might hurt people. Training is required both for the critic, who wants to support and strengthen the presentation, and for stu-

dents, who tend to take criticism personally and who need to understand that good criticism is not personal.

MM: Learning from criticism is not easy anywhere. At Harvard, I noticed that teachers and students were very skilled at criticizing others' work, but they were less skilled at writing or presenting a paper. Weaknesses they could easily spot in another's work frequently appeared in their own. On the West Coast, by contrast, in the classes I taught people were not good at critique. They were more concerned with making supportive comments to the author. There's something between harshly communicated criticism and no criticism at all, and that is being critical in a helpful way, being a critical friend.

HS: It's a communication skill, learning how to get the result you want from criticism. People always say to me, Hiroko, you can get whatever you want.

MM: Yes, because you know how to communicate. Again, there's something between being passive—just taking whatever you get—and ordering people around. There's a space where skillful communication can achieve a great deal. My husband often says to me, "If people only knew what you want, they would be happy to give it to you." An example of his principle occurred when we were in Orvieto, Italy. I went there to study the Signorelli fresco, *The Resurrection of the Dead*, in the San Brizio Chapel of the Orvieto Cathedral. When we arrived, we saw that the chapel was closed, curtained off and filled with scaffolds for restoration. I started to walk away sadly, but he found the head restorer's office and told her about my project.

The next thing I knew, we were sitting in a café on the square having coffee with the signora, after which she took me up on the scaffolding inches away from the frescoes, where one can clearly see the *journata* (the freshly plastered space the fresco painter expects to fill during the day), an experience I could not have anticipated and certainly could not have had if I had simply walked away. "If people only know what you want, they will be happy to give it to you." That's a good working assumption. If it doesn't work, well, okay, but to give up before you even communicate what you want is a counsel of despair.

Part II: Strategies

HS: That's exactly it! That's really the way. Inhibition is something we have to get rid of.

MM: Most of the time!

8

Style

> "Our aim is to reach a point at which we no longer see ourselves through the eyes of others."
> ~ FRIGGA HAUG

MM: I think that one of the biggest so-called successes of American media is creating a whole nation of people who think that skinny bodies are attractive and sexually desirable. I study historical European cultures that didn't think so, that *loved* flesh. The first widely available pornography (sixteenth century, illustrated narrative) adored flesh, the more the better. Flesh was also a mark of wealth in societies in which food was scarce.

Renaissance Europeans were also excited by different body parts than Americans are. Early pornography says nothing about legs, but loved plump arms, a rounded belly, and a place just above the buttocks called the *chute de reins,* which, in fully fleshed women, was dimpled. Because the most frequent occasion on which naked breasts were seen was nursing, breasts were not thought of primarily as sexual. The sexual breast was quite deliberately constructed in seventeenth century France when a public campaign urged women not to nurse their infants but to preserve their breasts for their husbands. Although sexual desire seems to be the most intimate aspect of ourselves, it is an extremely strong part of our socialization. For any society, the erotic eye is constructed and communal.

Part II: Strategies

HS: I love the women's locker rooms with their big bathtubs that can be found at Japanese hot springs; one can marvel at the many different bodies. I especially love very large women whose flesh goes on and on, like Fernando Botero's artwork. They are so sensuous.

MM: We've talked about our attraction to sumo wrestlers. I love flesh because I have trained myself to see through Renaissance eyes. But you've also said that you like sumo wrestlers because you enjoy flesh. Do you think that this is a cultural or a personal attraction?

HS: It is both. Sumo wrestling has existed for centuries; it is a national sport in Japan, and hugely popular in Mongolia and other Asian countries. It can be traced back to Japanese mythology, and it is closely related to the rituals and festivals of Shinto religion. One fascinating aspect of sumo wrestling is that no weight categories exist. Often a smaller and lighter wrestler beats a much bigger and heavier opponent.

I also feel a very personal attraction to the sport. When I was a child I used to play Sumo with boys. I was a tall, thin girl, but I was strong. Being a tomboy I had much more fun playing sumo and baseball with boys than playing with dolls. Later, when I lived in Tokyo, I saw sumo wrestling "in the flesh." The matches have their own ritual and momentum, which builds spectators' excitement. But also spectators who love the sport develop the ability to see, from the wrestlers' skin tone and color, and the suppleness of the skin, who is the strongest wrestler. Sumo wrestlers eat a great deal in order to develop flesh, but then they train for strength.

To change the subject from bodies to what we put on them: I'm very interested in fashion, because fashion articulates and defines the mood of the time. When I wear a new outfit I feel that I am wearing the "air" of that particular time. But for me, the latest fashion is not important; finding my own style is important. What I wear is a large part of how I communicate, and express who I am and what mood I am in.

I knew nothing about style until my late twenties and early thirties, but now wherever I am, I can always find my sort of outfit. I know how to make myself comfortable and stylish at the same time. When I was younger the thing I enjoyed most was shopping at discount stores that carried everything from very high-quality clothing with torn off labels to real junk—just piles and piles of clothes. I could easily spend two or

three hours picking up whatever interested me and putting it in the cart. The fitting rooms were like a girls' locker room where many women are trying on clothes together. Out of the great variety of clothing I almost always found something both perfect and still a great bargain. My favorite pastime! I like the concept of cheap chic. I like to combine something very cheap with something expensive. One must be one's own stylist, gradually creating a particular sense of fashion.

Japanese consumers are maturing these days. A few years ago brand-name goods meant everything. I knew young women who would skip lunch because they were saving to buy a brand-name bag. Some young Japanese women still care a great deal about the brand name of their clothing, but many consumers know how to be chic and cheap; they don't buy brands for the brand's sake, and they have found their own combinations of chic and cheap.

I am not good at makeup; I still don't know how to do it. I admire women who can use makeup well. I prefer to go without it, so I try to get away with as little as possible. If I have a really good haircut and an interesting manicure, I feel confident that I am stylish. Three years ago I discovered nail gel, which is different from enamel and can last up to a month. It was invented in South Africa. Professionals can create beautiful and unique nails with gel.

MM: As a teenager I was not allowed to wear makeup. All I could get away with was plucking my eyebrows, which didn't need it, and curling my eyelashes. During a time in which girls wore bright lipstick I felt that I had no face. As a result, I now love to wear light makeup, and would not leave the house without it.

HS: I start every day by trying to create an environment in which I look as good as possible, which gives me a lift. When I wake up in the morning, for example, looking in the mirror is one of the first things I do, so it helps if I find the right lighting and a good mirror. A good mirror and lighting can make you look—and therefore feel—good.

I keep clothing in the five different places I live or regularly visit—an apartment in central Tokyo, my work studio, my countryside house in Yamaguchi, our apartment in New York where my husband lives, and my daughter's place. In each place I can open a drawer and find my style. I

have been wearing some of my clothes for twenty or thirty years. I still love to shop at nice boutiques and find something I like on my way back and forth from business meetings. I buy clothes on impulse, sometimes just to cheer myself up. But now my closets are getting awkwardly full.

There are many occasions when I need to wear the right outfit to feel the confidence I need to communicate well with others. I usually wear Western clothing, but I also enjoy wearing kimono, continuing my mother's and father's tradition. There is an art in wearing Japanese kimono. One must be conscious of the seasons. For example, early spring is the perfect time to wear designs of plum blossoms, but by the next month it will be cherry blossoms. And in summer the pattern is different again, and then there are all the accessories, different underlayers, sandals, bags, and ways to knot the sashes; there are so many intriguing combinations.

I combine kimonos that were originally worn by my mother, my mother-in-law, and my grandmother, and I want to pass kimonos along to my daughters and daughters-in-law and granddaughter. The different elements of kimonos can be combined in endless ways and they are loaded with memories of the loved ones who originally wore them. Kimonos can be used and reused, so they are very ecological, too.

MM: I have a friend who is ninety-four years old, an art historian and a wonderful person. She is interested in other people, which I know from my hospice volunteering is very rare at that age. But I notice that she has stopped buying clothes, which I think is a bad sign. She has beautiful clothes, but they are at least twenty or thirty years old, and they do not fit her present lifestyle. So I am going to take her shopping!

HS: Interest in style is a way to maintain your curiosity about life.

MM: My mother always wore a girdle. I also wore a girdle when I was eighteen years old and looked like a pencil. Mother claimed that she was terribly uncomfortable without her girdle; that was because she had no muscles. In a sense, we still wear girdles, but they are our muscles which we have built up and maintain. She had an exterior girdle; I have an interior one!

HS: *Not* wearing high heels is part of my style these days!

MM: For me, not wearing high heels is more than a style; it's a statement. High heels are a sexual symbol in American culture, so refusing to wear them means that I'm not thinking of myself as a sexual object. I like that! Western men *must* look when a woman in high heels walks by. It is not a choice; their heads just swivel as if jerked by a puppeteer.

It's a question of who you dress for. Some women dress for other women, hoping that they will be envied, considered beautiful, or that the designer outfit they are wearing will be recognized. Some women dress for men, so that they appear desirable to men. With a certain maturity, you suddenly realize that you are dressing for *yourself*, because you enjoy looking and feeling a certain way.

HS: I was so impressed when you wore the short skirt when we met in Chicago last year.

MM: I bought that skirt at the elegant shop where my granddaughter worked. I was hesitant about it and I asked her, "Can I wear this skirt?" She said, "Oh yes, it's fine on you." So I dared to do it.

HS: That's wonderful! You're wearing it because you want to, because it feels good on you.

MM: Yes, but the older we get, the trickier it is to find clothes that make us feel good but don't make it appear that we are trying to look younger than we are. You've seen people who dress in a way that attempts to deny their age. One trend I see in older women is that they wear bright colors in order, I think, to distract from their own faded/softer face and body. I just want to look good in what I choose to wear. *I* want to look good, I don't want my clothes to look good for me.

I need advice sometimes so I ask my daughter and granddaughter, and they are brutally honest. My daughter criticizes all my pants. Once I bought a pair that I thought looked good on me. So when I went to lunch with her I asked her opinion. She took a good look from all angles, then she said, "Are they comfortable?" I replied happily, "Yes!" "Well," she said, "there you go." She thinks that if an article of clothing is comfortable, it is ugly! Then she said, "How many pairs of pants did you try on before you picked these?" Again, I said happily, "This is the first pair I tried on."

Part II: Strategies

Wrong answer! I am hoping that since she is presently fifty-four, she will soon discover "comfortable"!

HS: When it comes to clothes, my daughter, who is a professor, dresses more conservatively than I do. I am the one who likes to try everything.

MM: Yes, there's a certain academic uniform.

HS: Now she is pregnant, and I insisted that we buy some fashionable maternity clothes.

MM: I see many women now who do not buy maternity clothes, but just let their regular clothes stretch over their bellies. I saw a very pregnant woman with a bikini on the beach. Her belly was uncovered and she was either unconcerned or actively enjoying feeling the sun on it.

HS: I think it's wonderful. It is such a beautiful curve. It's a good thing. We used to feel we had to hide our pregnancy as much as possible. Now it is different.

MM: Mothers and daughters and the different kinds of interaction they have around clothes is so interesting. After my first divorce my daughter and I were very close. She was twelve. Although I did not complain to her about her father, I made her my friend and confidant in every other way. When she was sixteen, however, she suddenly seemed to despise me. Everything I wore was ugly; everything I said was stupid. Once she angrily told me that she liked her dog better than she liked me! I realized that, partly *because* we had been unusually close, she needed to create some distance between herself and me in order to become her own woman. This went on until her own daughter was born when she was in her late twenties. Overnight she warmed to me; immediately her voice was different on the telephone! Once she herself had a daughter, she was secure enough to acknowledge her love for me again without fearing that she would *become* me.

9

Energy and Power

MM: We need to talk about personal, social, and political power. Acknowledging that we have power and working responsibly with it seems to be difficult for women. Because traditionally we have not been given formal power in the institutions of public life, we have tended to create alternative ways to exercise power, not all of them effective, and some of them quite counterproductive. As women are gaining power in our societies, we need to find ways to implement the common good. In America it is often assumed that the accumulation of individual and group interests will produce the common good, but if each interest group thinks only of its own advancement, it is not at all likely that the common good will be achieved.

Power is potentially a good thing. We live after Lord Acton said, "Power tends to corrupt, and absolute power corrupts absolutely," so we are very aware of abuses of power. But the historical people I study thought of power as a very good thing indeed. They wanted strong rulers who could guarantee that they would not be slaughtered in their beds and that there would be food on the table.

HS: I believe that personal power comes naturally when you do something you believe in. Expressing articulately how much you believe in your project and how passionately you want it to happen gives you power. For example, my company has a bamboo project because we be-

lieve that bamboo has tremendous possibilities for environmental issues. It takes only three years to grow fully, and its roots are edible. Among other things, bamboo is natural, ecological, and beautiful. Often considered a cheap material, bamboo is actually a perfect substance for the future. We want to replace plastic, which causes many problems both on land and in the ocean. When we remember these principled reasons for promoting bamboo, our business difficulties dissolve.

MM: At Harvard I was the first and only woman on the professorial committee for several years. At that time, all decisions about hiring, curriculum, and administration were made by that committee. I felt that I had to be alert and active in order to create openings in the university for other women, so I couldn't just ignore or step away from the power struggles. But I wanted to find my own way to hold and exercise power. It was hard for me because I am not fundamentally a political person, but to deny that I had some power would have been irresponsible. Placed in a position in which my voice was the only representation for people who were not in the room, I had no choice but to enter the power struggles.

HS: Yes, we need power to make things happen. But sometimes it becomes a matter of playing a game, and in order to play the game effectively, a strategy is needed.

I try not to use traditional feminine behavior to get what I want, though it certainly can be effective, and there are times I realize later that I have made use of it. I don't want my behavior regarded as typically feminine. But I enjoy being a woman tremendously, so it's complex. My generation of women have been given the option of whether we will be housewives or career women or both. Women today have more options for many things than men. I think that women can be blunt without inhibition because they have not been socialized to institutional behavior as men have.

I'm grateful to my husband for the freedom I had in my early professional life. He has a good job that gives him confidence, status, power, and supports our lifestyle. Thanks to his career, when I first started out, earning money was not the main issue for me. I didn't need to accept jobs just for the money, and this freedom has helped shape my professional attitude. I know that kind of freedom is a luxury. Because of it, I bring

different attitudes and ways of thinking; I can be bolder, bringing unique and unconventional solutions to my work. Sometimes I am perceived as saying things that are unrealistically visionary—because I'm a woman; it is not necessarily bad.

Recently we were asked to design a proposal for a corporation about how to utilize a piece of property that they owned that used to be a school building and ground. They had in mind a very ambitious project for a huge chunk of vacant field; they had been working on ideas for the last eight years. The meeting was made up of all men and led by a man ten years my senior, who is very established in his field. I presented my proposal and he gave me a strong critique with sharp questions. If I had been young and naïve I would have taken it personally and thought that was the end of my pitch, but instead I just let him talk as much as he wanted, and then answered him straightforwardly without arguing.

Then, at a certain point, I made a very blunt comment, which I don't think a man would have made in those circumstances. I just told him that looking back, regardless of whatever feasible ideas they may have considered, no decisions had been made. For eight years these people had been talking without result. I said it in such a way that I did not offend them at all, and it brought us to a second level of discussion. Being a woman lets me make this kind of comment. When I take an unconventional approach I might be considered an artist, an absentminded professor type, or just a woman. Sometimes in a meeting I even articulate this as if I were reading their minds, *You think I just said that because I'm a woman*. We definitely have more freedom than men, and more fun. Even down to the choice of whether to wear pants or a skirt, or makeup or no makeup. Or I can enjoy wearing kimono—that's another option I have. When I deal with people outside Japan, being both a woman and Japanese gives me even more room for creativity. People are fascinated by Japanese food, *manga* comics, and other essentially Japanese cultural features.

My philosophy is to focus on what I have, rather than on what I lack. I don't try desperately to be something I'm not, or to have something I don't have. I don't try to be American or French or Spanish; I am Asian, and I enjoy being Asian. I use my difference as a tool to communicate better.

At one meeting where I was the only woman, I sensed immediately that a decision had been made even before the matter at hand was dis-

cussed. So although I had a proposal ready to present, I didn't present it. I excused myself before the end of the meeting and left. I did that to protect my project, not to waste it where it would not be appreciated. Although the project they had already decided upon was going to be done, I was certain that it would fail. Then, since my project had never been rejected, it would be available in the future. Sometimes one has to be bold and take a risk. I think women may be better at thinking outside the box than men, who in general are more traditional, more accustomed to doing things in certain ways. Women can be very creative.

MM: I agree that women are free to exercise ingenuity and creativity. We don't need to feel loyalty to ways of doing things that we did not invent and largely do not administer. We find our own way, and we do not want to revert to hoping that the big man will take pity on us and help us.

When I was an academic dean, the president of the institution once told me that he was afraid of me. He didn't explain, and I tried to figure out what he meant. I think that because I did not use "women's wiles" but stated as directly as possible what I thought should be done in particular situations, I was not acting like the women with whom he was familiar and comfortable. Therefore he did not know how to deal with me as a colleague. Like you, I am not willing to do the "little woman" act; I never even carry luggage onto a plane and then have to look around pleadingly for some strong man to put it in the overhead compartment. I have a friend who thinks this is silly. She says, "But that's why God created men!"

HS: I carry a bit of cash with me when I'm traveling and, if help is necessary, I pay for it.

10

Pleasure and Happiness

"The world is so full of a number of things that I think we should all be as happy as kings."
~ Robert Lewis Stevenson

HS: From our different cultures we bring wise words that help us articulate what we are learning about and experiencing in life. The aphorisms that arouse and encourage us also reveal our differences of perspective, social and institutional location, and cultures. They are sayings that worked for us; they may not work for everyone.

MM: I lived on energy from aphorisms for years. Snatches of poetry and philosophers' phrases have gotten me far. One example is Rainer Maria Rilke's *Letters to a Young Poet*. I was not the targeted audience for that book; it was written to a young male poet, and I was supposed to be what Rilke called "the maid" who supported, encouraged, and shared the young poet's experience (rather than having her own). But I said to hell with that role, and I took instead the advice to the young poet, advice to cultivate my solitude, to keep at bay others' demands, and to think about my life and its possibilities broadly and deeply.

People who are desperate for affirmation must grab and use what they can find, whether or not it is intended for them. My example here is

from the epic poem *Beowulf*. Beowulf's fighting men are being routinely slaughtered by the monster Grendel, so Beowulf goes to the monster's den in the deepest part of a lake to slay it. He carries a trusted sword; a page is devoted to describing this sword's exploits and triumphs. But when Beowulf enters Grendel's den and prepares to strike the monster, the sword melts. (It goes limp, a male fear!) So Beowulf grabs pots and pans that are hanging on the wall and slays the monster with them. Perhaps the example is overly dramatic for the point I want to make, which is simply that you must look around and find the resources you need, whether or not these resources were intended for you or whether they come with a guarantee.

Each of us has a belief about the nature of reality, and we busily gather support for our belief from the world around us. I have a friend who is desperately unhappy. He believes that the fundamental reality of the world is suffering, unfairness, and ugliness. I believe, on the other hand, that the world is fundamentally a "smiling place," as Augustine called it. Another favorite author of mine, the third-century philosopher Plotinus, said, "Beauty is reality."

My friend finds plenty of evidence for his belief that suffering is reality. I find plenty of evidence that the primary characteristic of the world is beauty and happiness. We are, of course, both right. But my belief makes me happy, even in painful circumstances, while my friend's belief makes him unhappy, even in circumstances that could be pleasurable. *He wants to be right more than he wants to be happy.* Of course, the world is not reducible to one or the other, but it seems to me more fruitful to believe that reality is characterized by love, beauty, and gift, and to seek evidence to support this belief. Because I see reality this way, I think of suffering, injustice, and ugliness as aberrations, as "unnatural."

But the way we see reality is also a matter of temperament. Is it possible for someone to change a painful and unproductive worldview? Can it be done with effort and concentration? By gathering evidence and support that conflicts with his view? What would this take? Psychotherapy to unwind the damaging view of what is most centrally real? Conversion to a religion that sees the world as created, ordered, and sustained by a loving deity? Clearly, arguing doesn't help! Reason is quite beside the point. After gathering evidence for the beauty and loving provision of the universe, the person could then be *both* happy and right! But that, of course, is easy

for me to see and say. More difficult, perhaps impossibly difficult, for my depressed friend.

HS: There is a famous saying that some people see a glass half empty, while others see a glass with the same amount of wine as half full.

MM: Do Japanese often see psychiatrists?

HS: Yes, depression is a huge problem in Japan, and suicide is common especially among middle-aged and older men. According to statistics, one in every fifteen people is depressed.

MM: What can we do when nothing helps our loved ones who suffer from depression? We can only be patient and loving.

I have another friend who had a wonderfully happy childhood. Her parents were consistently loving and responsive to her. She has been an adult for about forty years now, and has never been as happy as she was as a child. She longs for her childhood experience to repeat itself in her adult relationships, and it doesn't. I, on the other hand, had an unhappy childhood, and ever since I have been an adult I have been so happy and grateful to be in charge of my own life. Perhaps happy childhoods are overrated!

Many philosophers have examined the idea of happiness and tried to define what happiness is. Aristotle, for example, said that the highest human happiness lies in contemplation. Plotinus said happiness comes with having a vision of the One. I think that the mystery of happiness lies in a settled deep disposition of trust in the universe, a feeling of perfect safety in the universe, a confidence that whatever happens cannot destroy that safety. It is a feeling of belonging in the universe, that I am an infinitesimally small part, but always, no matter what happens, a part. Happiness is much larger and more intimate than having "pleasures," or having fun. It is so much stronger and more fundamental than the struggles and losses that come and go.

Often when I look back on my life, it is the struggles that stand out in memory. But struggles do not eliminate my feeling of the beauty and goodness of the world. At present, each of my three siblings has a different life-threatening illness. Even though I am very distressed about their suf-

Part II: Strategies

fering, I still feel happy in the broader sense of trusting the universe and feeling gratitude. Happiness is a choice, and for me it is always accessible. Certain music makes me utterly happy. But the natural world is perhaps my most trustworthy provider of happiness.

HS: I agree. When one has a basic trust in the universe, struggles, challenges, and problems are evanescent. No matter what happens, you find the courage to stand up again. Sometimes you don't know what to do and feel totally lost. But after a good night's sleep—or perhaps it will take several—something starts to bubble up from inside, something I call happiness.

MM: Yes, happiness surrounds us and forms an optimistic attitude toward the world. In my professional life, the time I was hurt the most was in 1991 when a review of my tenure book got an eleven-page review in the most important journal of religious studies. I have already mentioned this review. It was a horrible review; it just trashed the book. The reviewer even had the audacity to say that in one place I said something profound, but that I didn't know what I was saying. Obviously it hurt a lot. So, as I have described, I collapsed for a day. Then I got up and started to write again.

Against the ups and downs of professional life, nature has always been a solace for me. When I lived in the San Francisco Bay Area, wilderness was always a half hour's drive away—the ocean, Mt. Tamalpais, a small woods down the block from my hillside home—all these healed and comforted me. One day I decided that I needed to watch what the sky does during the night. So I sat with my dog on the hill above my house and watched changes in the sky all night, my sleeping children in the house below.

When I went to Boston to teach at Harvard, however, wilderness was at least an hour and a half away in New Hampshire. There were large park areas closer, but I couldn't feel them as wilderness when the trees had their names on them in Latin. I went to a psychotherapist to help me adjust to my new life at Harvard. When I complained of the lack of accessible wilderness, she remarked, "You're suffering from malnutrition!" She was right. I did eventually find food I liked in the immensely rich offerings of a great university, but still I hungered for the healing bounty of wilderness.

Pleasure and Happiness

Americans are socialized to seek entertainment in order to distract us from our needs and griefs. We learn as babies that someone should amuse us, give us a show. If we didn't teach babies to desire entertainment, they would be content to play with a little plastic cup for a long time.

HS: Yes. Pleasure and happiness have little to do with entertainment, with holidays and vacations, with getting away from ordinary life. Attentiveness to daily life, really noticing the details, *being there*, can make one happy. But we tend to think of work as something we do for the sake of something else, usually for money.

> "The life of the actively good is inherently pleasant.... So their life does not need to have pleasure fastened about it like a necklace, but possesses it as part of itself."
> ~ Aristotle

HS: I always prepare for the worst, then I feel comforted when what usually happens was something a bit better than the worst. So I'm pretty good at preparing for the worst, and as a producer it's my responsibility to do so.

I have had my share of "the worst," though. My little sister died of lung cancer at the age of forty-four. Two months later my mother died of cancer, and at the same time I had the major crisis in my marriage. In the midst of all those things I just wondered what else could come along to make things any worse. But in that moment I realized that whatever happens has to be better, and from that I received a sense of relief.

I was living in Tokyo and my sister was several hours away in Shizuoka. Every weekend in the months before she died I went to visit her. When she died, my mother was so ill that I couldn't tell her that her younger daughter had died. Two weeks before she died I spent the night in her hospital room, and she asked to talk to my brother and my sister, but still I couldn't tell her. I don't regret it. I do regret that my brother-in-law would not permit his wife—my sister—to be told that she had cancer, but that was common in Japan thirteen years ago. These days most people are told.

In my experience, happiness is momentary; it never lasts long. And sadness is the same. Even if the worst thing happens and I feel lost, at a

certain point I always find the strength and courage to stand up and start again. The past does not predict the future. Because I have confidence that no matter what happens I can always start again, I'm a happy person.

Margaret, I know you view your own culture quite critically. I feel the same way. But if I were asked to name a positive thing I have learned being born Japanese, I would answer that it's the inherent Japanese ability to enjoy a pleasant day, where no ambition for possessions intrudes. We can really appreciate and highly value something simple from everyday life. Like a bowl of fresh spring water, those nameless wildflowers in a field, a quick rain shower on a summer day, morning glories growing in an alley. Even keeping the house neat and tidy can give us joy. Happiness does not require drama or adventure. Contentment at the end of a good day is also happiness. Also I appreciate coming from a culture that treasures craftsmanship and artisan abilities. Japanese are attentive to, and appreciate detail, whether the exquisite design of an object or the careful placement of food for a meal, and good service at a small inn.

MM: One has to be a rich person in oneself before one can spend a day experiencing the richness of the world. One way I create richness in myself is to memorize poems I love. I love to walk around with long poems in my head. There is a certain intimacy in having a poem "by heart" that isn't possible when it is read. I recently read about a situation during World War II when it seemed inevitable that a certain family would be put in a concentration camp. The mother urged the children to learn poems to sustain them in the harsh experience to come. Memorized poetry is beauty that no one can take away from you. Music and art can be taken away, but not the poetry you've memorized.

Part III
TO HERE

11

Professional Life

"Three companions for you: Number one,
what you own. He won't even leave the house
for some danger you might be in. He stays inside.
Number two, your good friend. He at least comes
 to the funeral.
He stands and talks at the gravesite. No further.
The third companion, what you do, your work,
goes down into death to be there with you
to help. Take deep refuge
with that companion, beforehand."
~ RUMI

HS: I have four children; although each is interested in creating a good life for themselves, not one of them has sought a "secure" position, like a government job, or in a profession that guarantees a nice pension. It would be easier for me if they planned ahead and were more secure. I do find it curious, but I try not to worry.

MM: That's funny! Wherever did they get the ability to work happily without placing future security at the center of what they do?! *You* don't have a government job!

Part III: To Here

HS: It's true, I don't work from nine to five, and I don't know what I'm going to be doing in three years. It may seem risky and adventurous, but I have a safety net. There are people around me (and clients who trust me) that admire what I accomplish. Also, when our children were small, I was grateful that my husband worked hard and took care of us financially.

MM: That's very valuable. I also had support from my husbands during my schooling. At the same time that we see ourselves as independent women, the support we have received and relied on needs to be acknowledged. I would not have a doctorate if I had not been supported by my first two husbands!

HS: When I hire someone to join my team, I always seek people who can do their job without resentment. Also, I want people who are not doing the job just for money, but also for personal gratification. Those are the kind of people I love to work with. When you find someone like that you feel that anything is possible! And when I decide whether to accept a project I take into account not only the project itself, but also the client and whether he or she is someone I can work with. It is difficult to work with someone who is not doing their job out of delight.

I need to have my own space to create. I also need to be able to go to the computer at any time to communicate with my partners overseas regardless of the time difference. So I've created an around-the-clock work environment in order to cope with demanding project situations, especially with all the people working for me. But even when I approach a project with delight, motivation to accomplish the necessary details doesn't always follow. One strategy I use when preparing an event is procrastination. I research too much, read too many books, before I take hold of myself and say, "Just write something, put it down in your own words." Finally, I go and start cleaning the house as my last effort. It clears my mind and always works.

Another strategy: When I have a project to produce and no inspiration strikes me, I ask one of my staff members to initiate a proposal or spell out some concrete ideas. When I see that another person's work or ideas are far from what I envisioned, I realize that I am the only person who can do it, and therefore I must. Seeing someone else's idea focuses my attention and allows me alternative ways of approaching the project. When I feel stuck or too focused I risk becoming narrow-minded. Perhaps it's a

rather complex way to motivate myself, but sometimes my staff produces ideas that can be so inspirational and they delight me!

Changing your work environment can be a good way to face what feels like a dead-end situation. A quiet café filled with the fragrance of delicious roasted coffee and a big window facing the street, watching passersby. Or taking a walk somewhere beautiful—a forest, garden, or shrine; this is an excellent way to generate ideas. Or going to the sea and watching rough waves crashing. Sometimes, I watch the sky, observing the slow moving clouds and breathtaking color gradation of the sunset. And of course, great music lights up your mind and brings you some great inspiration.

When I feel stuck in planning a project, I write emails to my non-Japanese friends. It helps me understand and explain things in a different language and in the context of a different culture. Diverse people and perspectives stimulate and nourish my creativity. I find that the best way to develop ideas, or even to get ideas, is to talk to someone. But the choice of person is extremely important, even if we don't necessarily talk specifically about the idea. Sometimes we just talk about this and that. It's amazing how humor can stimulate one's thinking: a funny comment I read or hear, little funny things I notice, encountering someone with a refreshing attitude on life, can do it. Or sometimes, if I see a problem, I intentionally back off from it—mentally and/or physically—and it can suddenly seem more manageable.

MM: I think of delight as a responsibility. One must have a commitment to staying close to one's delight, not violating it by calculating which professional careers or fields have the greater job opportunities, refusing to say, okay, I love history, but it doesn't seem to have many job opportunities, so I'm just going to study computer science in which jobs are more plentiful. That's a violation of one's delight. When we do that, we get used up and burned out, because the delight has disappeared. It requires discipline to stay close to what delights us. I learned this from an author I've studied for a long time, Augustine of Hippo (d. 430).

"Delight is, as it were, the weight of the soul. For delight orders the soul ... where the soul's delight is, there is its treasure.
~ AUGUSTINE

Part III: To Here

Throughout our conversations we have advocated the practice of following one's delight. It would be dishonest, however, not to admit that for me the cost of motivation by delight has been considerable. The experience of teaching at Harvard was a strange combination of privilege and oppression. I was the first woman tenured in my graduate school, and many of my senior colleagues simply did not know how to relate to a woman as a colleague. Falling back on old styles of relating to women, they were either condescending or flirtatious. But a large part of the difficulty of teaching at Harvard had little to do with my sex.

The evening I arrived in Cambridge a colleague came to greet me and, apparently thinking he was doing me a great favor, warned me sternly that if I didn't publish, I wouldn't be there long. I was just out of graduate school; I had not published a word; I was terrified. Perhaps he actually *was* doing me a favor, however, because I subsequently put a great deal of attention on writing and publication.

I found a way to combine teaching and publication. I gave a seminar on a subject on which I planned to write. In the seminar I worked carefully with the students on the historical texts that would be involved in the project. Then I gave a lecture course, keeping extensive notes on my lectures. By then I had done both the textual work and the necessary research so I could write a book on the topic rather quickly. I also had the great benefit of having discussed the subject in detail with highly intelligent and critical students who could point out weaknesses in time for me to correct them.

Nevertheless, the workload was overwhelming. Now, when I am introduced before a lecture, the mandatory recitation of my book titles makes me feel very tired. I remember the labor! However, I have sometimes said that writing a book is like having a baby. Once I hold a book or baby in my hand, I tend to forget the labor. So then I am ready to write—or bear—the next one. I know what I *think* by writing, by covering the ground. It is a tremendous privilege. I write books to know myself.

> "I confess, then, that I attempt to be one of those who write because they have made some progress, and who, by means of writing, make further progress."
>
> ~ AUGUSTINE

Professional Life

"Publication isn't all it's cracked up to be. But writing is."
~ Anne Lamott

So Hiroko, neither of us had a path prepared by women who came before us and showed us how to do it. We have both had to invent what we do as we went along, and there's a lot of zest in that, but there's also a lot of stress. I notice that it took both of us rather a long time to become established in professions that delight us. Even though you had to invent yourself as you went along, Hiroko, as a cultural producer you are right at the top of your field; you are sought after; you have exhibitions all over the world. How did this happen?

HS: The beginning of my career outside of teaching was as a coordinator, an interpreter and facilitator of joint ventures between Japan and America for a subsidiary of a major technology company. I came into my profession little by little, starting with some consulting in which I could use my English and my international experience; then I went into event production.

My boss was a bit younger than me; his English was not good, which is why he gave me the job. Most of the time I translated for everyone at each meeting; afterward over a glass of wine or beer, I consulted with him about how things went. I discovered not only great differences between male and female points of view, but also how well we worked as a team. He was a gracious man who was very receptive to my advice.

The entire experience taught me that I am a make-it-happen person; my mind is always on what I can do to make a project move ahead. When I have an idea that I would like to make happen, I do it today! I just do it!

MM: When you are making it up as you go along, you do things in fresh ways.

HS: Yes! But sometimes it is not easy. Sometimes you are forced to do so. As I mentioned, five years ago I had to shut down my previous company due to sudden management changes in the corporate group of which my company was a part. I believed that my venture had great energy and we made important contributions to the group. Even my lawyer and CPA told me I shouldn't feel bad, that my company had been great for public

communication and corporate social responsibility. I defended our work at a stockholders' meeting, nevertheless, we were rejected by the board. It was a huge slap in the face, but ultimately I had to accept their decision.

So I coped with the rejection and in the end it was for the best. I went on to meet and work with many terrific people. The vision and mission of my work remains the same, but I have created a new work style. I needed to think about management in fresh ways. The name of my former company was Transform Corporation. In leaving that situation and starting fresh we transformed ourselves! Actually with a mobile phone and laptop, you can create a ubiquitous work environment. I don't even have to go to my office to direct the work, so I am free to concentrate on creative projects. I usually don't even need to tell my staff and my clients where I am.

MM: Recognizing and hiring talented people seems to be very important in your field. You have the ability to notice someone young who has talent, creativity, and ingenuity and you hire them. You let them do what they do best, and advance in the profession. In academic institutions, the career path is quite well laid out. We would never skip over the ranks and hire an excellent graduate student for a responsible teaching position. Before she would be eligible to teach in a college or university she must have a doctorate and well-reviewed publications. Of course, *on top of* the formal credentials, we also look for people with talent, energy, fresh ideas, and collegiality as you do.

HS: I love to identify especially talented young people and give them responsibility that allows them to prove themselves. It's really a pleasure. I've never advertised for employees, good people just seem to appear when I need them. My style of leadership is not to micromanage but to let the people I hire do their job. They know, however, that I make the final decisions.

Perhaps this style is simply a version of what a Japanese woman is socialized to do, namely, to enable and support others! I don't really enjoy managing people. Because I started my career as a teacher, my employee relationship is more like that of a professor to a student. It was particularly painful when I was forced to shut down my previous company, and to dramatically reduce my staff. Of course there were times before that when I asked employees to leave, but in many cases I felt they had learned

enough to graduate from the "Sakomura school"! But it is always difficult for me to let people go.

MM: You have found a way to keep the best of traditional socialization while using it professionally. That is a value that is important to both of us, not simply overturning our socialization and acting opposite to it, but keeping the best parts and making them work in new ways as professional women.

Women need encouragement because we are socialized to timidity. I think that is partly why I entered a field in which the authorizations are very explicit: you get this degree, then that degree; you publish a book, then another book. So I have that security, but you don't have that because you entered a field in which a list of degrees and publications is irrelevant. You are more daring than I am!

HS: I'm a gambler!

MM: Do you get your projects by word of mouth, by people hearing about something you've done?

HS: Yes, almost entirely by word of mouth. Looking back, it's amazing to me how such an unpredictable method worked.

MM: And they say you can't get here from there!

HS: It's about risk taking. Everybody takes risks, even—or especially—those who try to stay safe, to plan and control everything.

MM: All the security measures we put in place *deaden* life, and that's the worst risk of all, that your life may be dead while you are living! We all gamble with our lives on how to have a rich life.

HS: And we have to be very flexible, because if things don't go as planned, it's not the end of the world. In fact, you may learn something! Even when you think the worst thing has happened, it may turn out to be really positive. You never know.

Part III: To Here

MM: In Christianity it's called "living by faith"! To me it's not about faith in a particular outcome, but faith that things will work out, confidence in your skills to help them work out, and a certain optimism that all the worries you have today will end today.

HS: Tomorrow will be another day.

MM: Yeah, with bigger and better problems! On the subject of risk: I have a theory that Americans like to gamble because we don't like to take risks in our lives. We try to have everything planned, insured, and under control.

A century ago when my grandparents in England were young, my grandfather went to call on my grandmother. They barely knew each other, and she had two sisters, so the family didn't even know which sister he had come to call on. He asked for my grandmother and as they walked in a nearby London park he asked her to marry him. He said that he was going to South Africa the next day and that he would send for her when he had earned enough to make a living and establish a home.

She accepted. Four years later, having not seen each other again in the meantime, he sent for her and she came to South Africa and married him. And they didn't think, as most Americans do, that if the marriage didn't work out, they would simply get a divorce! They were happily married forever! Now that's risk! They gambled with their lives. We don't do that now; we want to be sure; we live with the person before we're willing to marry them, and/or we sign prenuptial agreements. So we gamble instead with games. That's my theory.

It is also highly important to know what you need in order to feel safe enough to take risks, to actually live a risk-taking life. I wonder what that is for you. Perhaps the excitement of pursuing your own way is enough "safety" for you. Most of us have an area of life in which we feel quite sheltered, and when that area is not threatened, we can be daring! In fact, it is quite important to be sure that whatever serves as our safety net is secure. Safety could consist of a relationship, a religious practice, a community, a job—even delight.

HS: Several friends of mine, women of the same generation, are real risk takers and I am so encouraged by how they handle challenges, but

still remain happy in their lives. For example, one friend simultaneously became short of money and found out she had cancer. She sold her large beautiful house on the hill and moved to a small apartment near the ocean and concentrated on curing her disease in her own way. Instead of having surgery and chemotherapy, she went an alternative experimental route. She has been doing remarkably well and works energetically as ever. She knew how to ask for help when she needed it. Instead of being isolated by her difficulties, she openly explained her situation and asked her friends for their help. I respect and admire her attitude. She cultivated her own safety.

Is excitement of pursuing my own way enough "safety" for me? That's a very good question. Owning a company, especially a small venture, means you have to act. Otherwise nothing will happen. You must manage everything—projects, payroll, employees, everything. It all depends on you. Your employees' salaries depend on your decisions about what will be successful. They must trust you. It's a huge burden but at the same time, your responsibility gives you power and energy to keep you going.

When I was a teenager, my father challenged me by asking, "Are you looking for a job with guaranteed income or will you cultivate your own exciting life to bring you money? At first as a teacher I chose the first path, but eventually I also chose the latter one. And at that time, I made the decision for myself.

MM: It's good that you knew early that you couldn't cope with a salaried nine-to-five job, so that you didn't waste years in jobs for which you were temperamentally unsuited. Boredom is very stressful.

HS: The kind of work we do from delight doesn't bring us huge amounts of money, but it does reward us in other ways. I would be happy to earn ten dollars more than I spend. I don't have to be rich. On the other hand, money represents others' appreciation for my work; it's a measure of thanks. You and I are lucky we can combine jobs that delight us while earning a living.

Many people start out thinking they will love their job, but somewhere along the way, because of the organization or the working conditions, they begin to feel that they are not treated well and that's when feelings of resentment start. I have pleasures and rewards and also failures.

Part III: To Here

When things fail, when I'm disappointed and discouraged, I think about what went wrong and once I think it through, I can get beyond those negative feelings. In a way, I enjoy risk taking since it keeps me from ever getting bored.

MM: I'm the opposite of you on that. No matter how small a salary, I like to know what I can count on. Even when I was poorest—in school, divorced, and with two small children—I always had savings. I think it comes from having parents who lived during the Great Depression of the 1930s and were permanently scarred by it. They passed on to me their caution with money, so I'm not risk taking in terms of money. As I have described, I do take risks in terms of ideas. I publish ideas that challenge common ways of thinking and seeing. That's very zestful for me, perhaps in the same way that deciding from one moment to the next what you are going to do is exciting to you.

HS: It seems that the only way to minimize risk taking in my business is to keep producing high-quality work and finding creative solutions, both innovative and budget-wise, so that everyone involved is satisfied and feels treated fairly. Then, eventually the result will bring us more opportunities. That is my belief. All I can do is my best right now and not fear for the future. I'll take care of that when it comes. I have to let go and trust that ultimately good things will happen. I am always looking for better ways to organize, manage, and create a working situation so that people with different tasks and locations can communicate well. I love to work with high-level freelancers or small units of creators. I build a team specific to each project with the best people. When the project is over, I say goodbye. That's my way to minimize the risks incurred in keeping a large staff occupied and paid.

MM: But that also entails another kind of risk. Instead of working with people whose capacities and skills you know, you are always working with strangers. So you have to have confidence in your ability to hire good people, people who are good at what they do.

When I was hiring people as academic dean, I made mistakes. I remember one woman who came into my office for an interview. My first impression was "substance abuse," but I talked myself into thinking in-

stead "*recovering* from substance abuse." Well, she wasn't recovering, and I had to fire her two months later. That incident eroded my confidence that I have the ability to evaluate people accurately. You must have much more confidence than I in your ability to judge people.

HS: Actually, that *is* something I'm good at. But it's also one of the most challenging parts of my job, trying to find the right people for the team.

MM: But what if they're just *not there*?

HS: Well, somehow I seem to be lucky so far.

MM: Not lucky—skilled! You also have years of experience that support your confidence.

HS: Sometimes I have problems, especially with people I didn't pick who may come with the project. But even problem people can be useful in consolidating the rest of the team. The "black sheep" can create a certain dynamic that makes the others pull together more purposefully.

MM: I haven't seen you when you had to be tough, but there must be those occasions.

HS: Oh yes, frequently I have to be tough. But at the same time I don't like to use my power in a domineering way. I try to distribute my power among the team. I am strong, but I try not to come on strong. I try to enable rather than dictate what must be done. I prefer to be accepting and encouraging.
But mainly I am flexible; I try to embrace differences of opinion, but always find a way to make things happen. Intuition is also important. If I sense that something is not working I don't push further. I just back up and wait for the next opportunity. I also observe and analyze people carefully to see what strategy will work, and I try to be tactful.
My childhood experience helped. My family was different than most families in that I was exposed to many different people in my home. My father's company employed about three hundred people and we were con-

Part III: To Here

stantly entertaining at our house. Sometimes young employees even lived with us. Relatives were also in and out of the house and I had the chance to observe many types of interaction.

MM: And you have extended your childhood ability to watch people and consider how best to communicate with them into a successful professional style.

HS: Sometimes I use humor.

MM: In the United States we tend to separate professional colleagues and personal friends. In academia it's a little different because we have common interests and so we do have personal friends among our colleagues. I think that's not often done with business colleagues, however.

HS: I was born right after World War II. It was a time when people drew together to support each other in rebuilding a stable Japan. When employees had problems they would talk to my father and, in general, he spent a lot of time socializing with people from the company. These days that probably doesn't happen; there's a different style.

MM: You said once that you always like to be in the background. You make things happen and then you place somebody else in the limelight. This is your self-image, but I think that it's not quite true.

At the events surrounding the Shinjo Ito exhibitions, you were always in front of people, describing how and why you made the choices you made about the exhibition. Because you love what you do, you described it fluently and enthusiastically and you didn't notice that you were in front of people! That is just like me in a classroom. I have to be talking about something I love so that I don't notice myself talking to a roomful of people.

HS: So there is a gap between what you are doing and what you think you are doing?

MM: Yes, we have our fictions about ourselves. We are always our own favorite characters in fiction. What matters is whether our fictions about

ourselves enable or impede us. Our fictions have not inhibited you or me. They have made us feel safe. You feel secure thinking you are always in the background when, in fact, you're not. And I don't notice that I'm standing in front of people talking when, in fact, I am.

The first time I was forced to notice myself in front, talking, was when I was going through menopause. I got hot flashes in the middle of a lecture. My glasses started to slide down my nose, and I had to surreptitiously wipe sweat from my face and sometimes take off my jacket. I became self-conscious in a way I was not used to; I became aware of my body instead of my subject, which until then had completely held my attention.

To summarize: there are some striking commonalities in our ways of thinking and working, despite great differences in our professions. Neither of us simply slipped into professions that were easily available to us. Both of us approached our professions thoughtfully, recognizing that they required courage.

We have continued throughout our careers to consider carefully the choices we make and the risks we take. We are both committed to motivation by delight; to an ability to understand defeats as opportunities to learn, revise, and change ourselves and our projects; to the conviction that the necessary tools of our trades are skills that can be learned, not inborn qualities that we either have or don't have; and to the recognition that to a great extent we are making up our professional lives as we go.

HS: We also value creativity; we enjoy people; we need a certain amount (though different kinds) of solitude, stability, and safety; we expect and enjoy continuing to learn, and we are committed to activities and attitudes that will enable us to feel alive all our lives.

MM: These commitments are as true of our personal as of our professional lives. Given the fundamental difference between a career in academic institutions and a career as a cultural producer, the difference between Japanese and American society and institutions, and our personal lives, I suggest the fundamental commitments we have mentioned can be tailored to fit any number of particular professional niches.

Part III: To Here

HS: We talked about "safety" in our professions and life, but you and I are taking risks in our own ways.

MM: Yes, but within the particular kinds of safety we need in order to take those risks.

12

Religion

HS: Motivation by delight requires a certain base, financial and emotional. It's difficult to work from delight if one is anxious about the necessities of life. But it also requires that one maintain a larger vision; some call it spirituality. Many people have lives that leave them exhausted at the end of the day, unable to remember or articulate their central engagement in the world. Do you do something particular in order to grow spiritually? You were born into a Christian family and Christianity is still your religion. Do you go to church? Do you pray?

MM: I go to church for two basic reasons: I value the community and I value ritual. I think ritual is important for marking stages of life and commitments. My religion is not about believing certain doctrines or creeds; in that sense, it is highly untraditional. I also like going to church because it re-paces me. I rush around all week, and then I go to church, and I just sit there for an hour and think about where I am in my life.

Also, I pray every day, but not in traditional ways. I do not ask for things. For me, the feeling of gratitude *is* prayer. If prayer is in any way separate from the rest of my life, it is simply in noticing that I am grateful for my life, for beauty, and for the people I love. When I live with gratitude for things I did not, and could not, produce for myself, then I think of myself as living prayerfully.

Part III: To Here

> "Prayer is properly not petition, but simply an attention to God which is a form of love."
>
> ~ Iris Murdoch

Yet I have a love-hate relationship with organized religion. On the one hand, the resources are so rich. On the other hand, people have used religion as an excuse to persecute others who believe differently. My church, the Episcopal Church, is, for me, uncomfortably class specific in the United States, though this is not true in other countries. It is largely a religion of the wealthy, and its members vary between rather extreme conservatives and very liberal and progressive members. Episcopalians (America) and Anglicans (England and Africa) still fight internally over whether gay and lesbian people should be ordained. Nevertheless, for me, having a community of people who are at least *trying* to be loving is consummately valuable. There are other groups in our society that are committed to loving and caring for others; organizations that responded to the AIDS crisis in various ways and hospice groups that are committed to loving care for sick and marginalized people, often in more direct and effective ways than churches. But I have primarily experienced social concern and care for individuals in church settings.

I have been a member of the Episcopal Church for about thirty years. The Anglican Church was my grandmother's church in England. After my first marriage (to a Presbyterian minister) I didn't go to church for about a decade, but eventually I began to feel the lack of a community of people who go through life together, who are there when you're having problems or on occasions of great joy. And I enjoy watching the children grow up and the old people get older. It's just very rich to me to be part of a "beloved community." Also, most American people who don't go to church don't sing, and I love to sing!

HS: So in your daily life you have several communities: your family, your husband and children, your professional circle, your community of hospice volunteers, and your church community. You have five or six very important communities.

MM: But somehow the church community permeates all my communities. I bring my other communities into that space. The church com-

munity is regular, every Sunday. It's a commitment. It's important to me that the church is a voluntary community; membership is not established by birth, family, or profession. A sociologist recently did a study of bowling leagues in the United States. He found that people who participate in voluntary communities are more civic minded, more concerned for the common good, than those who do not. Someone else did a study of people in choirs and found the same thing. People who sing together breathe together, and apparently this makes them understand at a subliminal level that they are members of a larger society.

I do need to participate in a church where there's integrity in the way things are done. For me, that has to do with serving the world, making a small difference. My church feeds street people every week. And it's important to me that I go to a church that blesses gay and lesbian committed relationships. Love is bigger than the way most of society conceptualizes it, and when people love one another and want to have their love for one another recognized publicly, I believe that they should have that acknowledgement.

HS: So your commitment is to what? To the community?

MM: Yes, to the beloved community. I don't even like all the people, but that doesn't matter. We are all very human, full of faults, but since we are part of the community it doesn't matter if I like them or not. They are each precious.

People often leave a church because they don't like something about it or the people in it, but I think that churches are very flawed human institutions. I don't expect my church to be perfect or even wonderful; a perfect church will never be found. All I expect is a community of people who are *trying* to be loving. Trying, and failing a lot of the time, but *trying*.

HS: I haven't found that. If I don't like the people, I don't go.

MM: I like almost all of the people, but my commitment is broader than to the community. My ultimate commitment is to the outrageous, counter-cultural, counter-experiential claim that the center of the universe is love. I "believe," that is, I don't *see*. So when we truly love, we are connected to our source. "God *is* love" (1 John 4.16). We haven't yet

Part III: To Here

taken that statement seriously enough. Augustine said that is all you need to know about God. Most Christians know far too much about God, far more than *can* be known, and the excess baggage conceals that simple statement, "God is love."

Contemporary Westerners don't have images that help us conceptualize, and thus practice, love. The dominant Christian image, the crucifixion scene, suggests that God's love for the world is best demonstrated by the sacrifice of his son to achieve the salvation of the world. But this is not part of my own religious sensibility. When I was in Japan I was surprised to find that Japanese Christians do not like crucifixion images either. In your hometown, Yamaguchi, Hiroko, I found only one small crucifixion scene in the Roman Catholic cathedral, and it was on the back wall of the sanctuary. In the West, there is usually a large crucifixion scene in the front (apse) over the altar.

Actually, Christians do have other images that present a different image of God's love for the world. The major image of the late medieval and early modern West was of the Virgin Mary with one breast exposed to feed the infant Christ. This image suggests that God's love for the world is primarily demonstrated in the provision of life, nourishment, and daily care—a very different interpretation than that of a crucifixion scene.

I understand the idea of "sin" by which every human act has an admixture of greed or self-serving. It often seems that people are a sorry lot! But I think the way to address that is to work patiently every day to become a loving person and to place one's energy on the side of building a loving society, rather than seeking personal salvation.

HS: So you treasure community and ritual. That's why you are willing to overlook the church's all-too-human problems?

MM: Yes, even though for me religion is not about beliefs or doctrines, I do find the myth of a perfectly loving human being very powerful as a model that Christians try to imitate in our own particular circumstances—albeit failing much of the time. That myth is a way to spell out, or recognize, what we are trying to do in the world. That's how I think of the significance of the founder of Christianity. But of course, I think in very idiosyncratic ways.

As I have mentioned, my parents' religion was very oppressive to me as a child. My parents' God was a God of judgment, always scrutinizing me for evidence of my wickedness. I never fully internalized this God, but I desperately wanted to be loved, so I went through the motions of attending church and youth groups, even memorizing large passages of Scripture. In my childhood family, beliefs were important, but they were not the most important thing. Being "us" was the most important thing. "Them" was out there, threatening; there had to be clarity and precision about our difference from them. The ritual moment that marked this difference was baptism.

As an adult I read Dylan Thomas's *Under Milk Wood*, a narrative about the inhabitants of an imaginary town in Wales. I was amazed and enlightened by the "Sunset Prayer of the Reverend Eli Jenkins" in which he expresses assurance that a loving God will "see our best side, not our worst." It was amazing to me to imagine such a God. My parents' God was always on the watch for, and ready to judge, our worst deeds. Later, of course, I came to have a God that notices neither, but is—also in the words of Dylan Thomas - "the force that through the green fuse drives the flower." A God that is, in the words of St. Augustine, "nothing other than life itself."

Religion has a bad name in both of our secular societies. In the United States, religion is seen by many people as constricting, and churches as self-serving. Many people think that religion frowns on sex, bodies, the natural world, and pleasures of all kinds. But religion should be about enhancing life in this world by helping us be attentive and grateful.

> "Her religion gave her solace ... rather than guilt."
> ~ ANNA CLARK

HS: I also like ritual as a form of orientation in life. I was born in a family of Zen Buddhists. My grandmother prayed and chanted a sutra every morning and evening. She wanted me to join her praying before the family altar. As a child I memorized sutra. Every month there was a day dedicated to the Buddhist spiritual leader. Instead of a regular breakfast we had a bowl of rice and pickles. I am also influenced by Shinto, in which there is no interest in a life after death, but only in the present moment. In every shrine you bow twice, you clap your hands, and you ask to be

purified and protected; you ask that all evil will be driven away and that you will be given happiness. Although I don't go to the temple every week, religion is part of my everyday life. Every morning when I boil water, the first cup goes to my altar and I pray to my ancestors and the Buddha, not directly wishing for anything, just thanking them, and saying a very short Buddhist chant. These are the exercises that help me appreciate what's around me.

When I have a problem or when I don't know what to do, I go to a big shrine. The nearest to me in Tokyo is Meiji shrine, which is built on a huge park; it's a beautiful place to take a walk. I try to go there early in the morning and walk around to calm myself, to drive away evil spirits. Its simplicity in design, its way of teaching that we are a part of nature, and its closeness with mythologies fascinate me. It's a place where I find serenity in natural beauty. Having a moment which reminds me that I'm part of nature, is critical for helping me cope with everyday problems and difficult situations.

I have also been exposed to Christianity. I went to a Catholic school in Yamaguchi; also, in my senior year in high school I lived with the family of a theology professor in Virginia; and later, back in Japan, I went to International Christian University in Tokyo. My wedding ceremony was held at the ICU church. I have experienced different religions and whenever I have a moment to do so, I meditate, regardless of whether I am in a temple, a shrine, or a church. Recently I have recognized that I am essentially a Buddhist and I would like to increase my participation in Buddhist teachings and practices.

Margaret, you and I participated in meditation training with Buddhist priests as part of the events associated with the Shinjo Ito exhibition in New York. During the meditation, the priests came around to each person to offer some words of advice. I was afraid it would be like the general advice in a fortune cookie. But the advice was not the main point. Meditation was a way for people who had been looking at the sculptures to think about that experience together.

MM: The priest who came to me suggested that I seek balance in my life. Of course that could be considered fortune cookie advice. But I decided to consider it more deeply. In my life, the highs are really high and the lows are really low, so I thought that it would be a good thing for me

to work for a balance in which I don't just ricochet from one extreme to the other.

Pondering this advice for weeks and months after the experience, I finally understood the concept of balance. Balance is not a dilution of two extremes to a watery middle. Rather it is about holding two extremes together in a very energetic tension. For example, it does not mean that when I am extremely happy I should remember my sorrows in order to modify my pleasure; or, if I am experiencing grief or pain, that I should remember happy moments. Rather balance is about experiencing my life *as a whole* that includes—that holds together—both happiness and sorrow. It is this whole that is my life, my particular and unique life. When I experience the whole, I experience its richness and beauty. Neither happiness nor sorrow dilutes or erases the other. Neither one alone is the truth of my life. It's the richness of the mixture that creates the beauty.

In our time there are not only real options about which religion one adopts, there are also secular alternatives to religion. The word "religion" is itself so abused; perhaps we should speak instead of values, of how values are chosen, scrutinized, revised, and communicated to children. I don't need the word "religion" for anything. I am happy talking about community, ritual, values, relationship, and world views.

13

Society and Public Life

MM: Interest groups are presently flourishing in the United States. These advocacy communities, based on race, gender, sexual orientation, ethnicity, and many other concerns, are important to alert the society to its own economic injustice, unfairness, and hatred. Yet it is also crucial that we imagine and begin to construct a society built on the *common good*. This is the dream of democracy, but the dream is flawed by the assumption that if each interest group advocates its own good, somehow the common good will be achieved. Can we build a society in which individuals flourish and in which no minorities are stigmatized, marginalized, or denied equal rights and privileges?

But let's talk first about Japanese society. I am learning a great deal about it from you. For example, I had not known about the prevalence of contract jobs, in which a person is employed for three months or a year, but with no assurance of employment beyond the short-term contract.

I thought that in Japan businesses were like extended families in which people are cared for all their lives.

HS: Workplaces used to provide lifelong employment. It used to be that once you were employed you could stay in that company until you retired. The company became the employee's community, but this is not the case any longer. It's a tremendous transition in Japan because we are a society accustomed to long-term employment. Presently in Japan

even major companies have started to lay off people. Companies are also outsourcing. And because young people are not having many children, schools are closing or consolidating.

MM: We have a similar phenomenon in American universities and colleges. Many qualified teachers are what I call "academic migrant workers." Unable to find tenure track employment, they are forced to take one year jobs. Then they must move on to the next short-term or part-time appointment. These part-time or short-term positions do not come with benefits such as health insurance and retirement investments.

It should be gratifying to teachers that so many young people want to get doctorates and teach. It must mean that their teachers have made the academic life look interesting and rewarding! But when many graduates can't find jobs, it is not so good. Few people in America can make a living doing what they love most.

HS: Scarcity of employment and anxiety about whether one can keep eating and feed one's family undermines community. One's neighbors begin to be seen as competition rather than as support and help. But there's also a certain ambiguity about community. In rural areas, villages used to be very strong communities in which there was little room for individuality or creativity. That is why, in my generation, people did not want to stay there. Instead, they went, as I did, to big cities to study or find work as a way to avoid conforming to the pressure of the community.

MM: Which, I imagine, people of your generation experienced as suffocating. So how do we get it right? Too much community is not good; neither is not enough community.

HS: Right! In Tokyo there are so many huge apartment complexes. Many people don't even know who lives next door to them. Being in a big city one can be totally anonymous, the extreme opposite of being in a suffocating community in which everyone knows everyone else's business, who is related to whom, or who is doing what with whom.

MM: I see, so resistance to constraining families and communities has created an anonymous society, at least in the cities. Large changes in a

Part III: To Here

culture leave so many people caught in between. Neither what's coming belongs to them, nor what has been, leaving them without resources.

HS: My husband's family has already purchased a grave plot in the city. I took my children there and explained to them that only the eldest son could be buried there. My son burst into tears; he wanted the whole family to be buried there, but the others will have to find their own burial place.

Even in large cities, however, it is possible to form neighborhood communities. I have fond memories of the one I had as a young mother. Our neighborhood was full of parents who had children around the same age. We helped and supported each other. Also, every district in Japan has a shrine and a festival in that shrine every year. Festival days reinforce neighborhood communities. Also, children learn about community through sports, being a part of a team. Teamwork and team spirit are always encouraged in Japan.

When we returned to Tokyo from San Diego my youngest child was three years old. We lived in the middle of Tokyo and the children could walk around by themselves. We let the youngest child go by himself to buy two things from the nearest shop, a bag of sugar and a jar of mayonnaise. He carried the money in a plastic bag. We waited for what seemed like hours. Finally the boy came back with a huge smile, having been treated well by the shop owner who even gave him some candy. That was one occasion on which we felt the reality of our neighborhood community.

On a different topic, I have been wondering since our conversation about religion, whether you think that everyone should have the goal of endeavoring to become a loving person?

MM: Yes, but the conditions a person needs in order to become loving are complex. If people are hungry or worried about the next meal, they have no leisure to cultivate loving generosity. We don't do a good job of providing for people's basic needs in the United States. Our society is becoming meaner every day as social services and health care are eroded, and more and more people live under the poverty level. There is a very powerful book by two sociologists, Marque Miringoff and Marque-Luisa Miringoff, who have tracked factors by which the common good can be measured. They show that since 1970, even as American society has be-

come richer, it has become more cruel to vulnerable people. Health care is rarer; there are more teenage suicides; the income difference between rich and poor had widened; there are more children living in poverty. We are the richest society in the world and yet we do not provide food and shelter for all Americans.

At the other end of the spectrum are the people who can never get enough. They get richer and richer. It's a painful situation, and we are all complicit, because we have enjoyed the benefits of living in a wealthy society for so long without effective protest.

HS: In Japan the voting rate is low, especially among the young. There is apathy, a feeling that nothing can be changed. However, large political change *has* happened in Japan. Japan's Democratic party, which focuses on making things better in people's everyday life, was elected recently, which broke a sixty-year period of leadership by the Liberal Democratic Party. Nevertheless, things are still a bit chaotic. What we are facing requires more than just a change in leading political parties. *How* to create change is the big question. *How* can we make things a little bit better?

MM: This is one of those "which came first, the chicken or the egg?" questions. Should we focus on changing societies? Or should we put our efforts on individual change? If I say, okay, I can't make changes in society, so I'll just work on changing myself, then I put a lot of attention on myself, rather than where it could be making some small difference in the world. I think that the answer is that there has to be a balance between attention to oneself and attention to the world; you can't pour out your energy continually without burning out. In order to be of any help in the world, we must cultivate an inner center, a place of repose and refreshment. But it is so hard to achieve that balance.

HS: I travel so much, three days here, three days there, always in big cities. In the last month I have been in Chicago, Los Angeles, Paris, Madrid, and London. I am finding that all over the world young people are being paid less. It hurts me to see the suffering. Many young people struggle without any hope, and there are a few very greedy people. The gap between the rich and the middle-class person is becoming bigger. People in part-time jobs work and work, but they do not feel secure, even

Part III: To Here

after years in their jobs. Their income doesn't allow for planning even two years ahead. The values created during the twentieth century have done great damage—values of individualism rather then the common good, and consumerism rather than the creation of a just society.

MM: It's incredibly difficult to change a society's values. In the United States, during the Vietnam War, mass marches and protests did seem to make large parts of American society recognize that war is a bad thing. But now we have gone to war again. War permeates and demoralizes the whole society. Large numbers of veterans of the Iraq War have committed suicide.

HS: How do values change? It happens slowly, but we don't have strategies that work to effect more rapid change in values. Do you think that if everyone had satisfying lives our collective values would change?

MM: Sure. And it is important to notice and call attention to the changes that are already underway, so that people gather hope and energy to go further.

For example, changing gender arrangements and expectations are beginning to produce more satisfaction in people's lives. This is really an incredibly massive social change. Every society in the history of the world has had rigid, nonnegotiable gender arrangements that dictate roles for women and men. But presently, in American society, it is generally acceptable that a man can stay home with the children while a woman can have a professional career. When people are encouraged to do what they delight in, rather than in a role prescribed for them, they are happier and therefore more loving.

Values are also constantly being changed by media. Usually I am very critical of American media, but I must acknowledge that a change has occurred for which I give media a large share of the credit. In the past twenty years, smoking has changed from being an attractive activity in movies, books, advertising, and television, to being frowned upon by most Americans. Formerly, the air was owned by smokers. An academic like myself, who spent her early career in seminars that were blue with smoke, now enjoys ownership of the air! This is an example of what media can do without being moralizing. I also know graphic artists who worked

hard, in the wake of the AIDS epidemic of the 1980s, to promote the idea that safe sex is sexy.

But media is not always as beneficial as in its campaign against smoking. It so often depicts violence as the solution to social and personal problems; it could do much more to make nonviolent resolution of problems appealing. But I fear that a society trained to expect and enjoy screen violence would find this boring.

HS: Another positive change in values is greater general awareness of the need to preserve the earth's resources. Many people are buying food that is seasonal and locally produced. Local cultures are also more appreciated.

MM: Any growth or improvement in the self must be in interaction with our society. It might be gratifying to help oneself to a happier life, but I couldn't be content with any strategy that did not also relate to helping one's society. I need to feel that I am part of a movement toward the *common* good. It has to be *both* about me and the common good.

14

Aging

"This is what growing old is all about.... You get *variations* of what you need. You go into the world thinking you still know what you want, and the world says, How about considering this instead?"
~ Dennis MacFarland

MM: Since I am more than a decade older than you, Hiroko, I guess I'll probably have more to say about aging than you! It's a tremendous privilege to have many years in one's memory bank. It's challenging, but also richly rewarding to live in one's whole life, not just in the present moment. I am also learning that each age has its own advantages, with different privileges than those of other ages. To clutch the advantages of another age and to grieve over their loss is to miss the privileges of the age I am.

HS: I dislike all the talk about "anti-aging" in both American and Japanese societies. This rhetoric implies that getting older is a bad thing, and that it can be avoided by taking a certain pill or using a certain face cream, or by cosmetic surgery.

MM: When I had my sixty-fifth birthday, I began to look for the advantages in being older. The first advantage I discovered was this: earlier

Aging

in my life, I felt that I had to try, sometimes again and again, activities that I was neither good at nor enjoyed. I came to enjoy doing a few of those things; sometimes the things that initially felt most alien turned out to be the most interesting and fruitful. But some didn't. So I made a list of things I would never again require myself to do. My list did not include things I have never, and would never, do anyway, only things I had done enough to know I didn't want to do them anymore.

The list included skiing (I got cold and I got hurt); camping (massively uncomfortable); preaching (I didn't have a clue as to how to do it; I just gave mini-lectures); seeing a counselor or psychiatrist (if I can't do my own life by now, when?); and taking snapshots (one too many pictures of large white refrigerators with a quarter of a human being on the side). Invited or urged to do any of these things (and more) I would henceforth let myself say simply, "I'm too old!" My granddaughter thought my list was a great idea and said, "Can I have a list, Granny?" "No!" I said. "You're eighteen years old! You have to try things in order to figure out what you enjoy and don't enjoy. You can't just guess in advance."

> "Glad to have ridden the big waves,
> Glad to be very quiet now."
> ~ MAY SARTON

When I had my seventieth birthday I discovered yet another advantage of my age. The French have a word for it: *quiquengrogne*. Roughly translated it means, "What the hell!" It suggests a certain insouciance and daring that I didn't feel in earlier years. It means saying what I think and doing what I want to do without worrying so much about whether it is the "right thing" to think or do.

It requires an increment of courage and confidence. When I told my granddaughter about *quiquengrogne* she said with dismay, "Oh Granny, you're going to be hurting people a lot." It has not worked out that way in practice. Because of "what the hell!" I tell people I appreciate them, or that something they did was generous or beautiful. I would have been too busy or too shy to do this earlier. Interesting to see that what I had repressed was not negative but positive comments. *Quiquengrogne*!

One of the most difficult aspects of old age is the gradual—sometimes rapid—losses that occur in body and mind. Being someone who

exercises daily and endeavors to keep my body and mind agile, I anticipate with some aversion the inevitable loss of intelligence and strength. A sculpture, Rodin's *She Who Was Once the Helmet-Maker's Beautiful Wife*, is of a seated old woman, naked, sagging and bloated. At first the sculpture made me cringe at the thought that I will someday look like that—if I live long enough. But I committed myself to contemplating it—across several months—until I was able to see, not only a beautiful sculpture, but a beautiful woman, a woman beautiful in her well-used body. Our culture does not encourage us to see beauty in bodies that do not fit the media consensus on what a beautiful body looks like. So we must train ourselves to see the beauty of all bodies, to see the *life* of the person as her body reveals it.

HS: One of the most energetic, talented, and happy colleagues I have passed away recently. I hadn't known she was ill. She was a great mother and wife and after the funeral we were invited to a small room to share our thoughts of her. In that room there was a series of pictures of her; I was especially moved by the photos taken while she was in hospital. She wore a beautiful expression that showed her acceptance that she was ill and was dying. There were also happy photographs of friends and family at her bedside. Even though the pictures showed her in the process of dying, they inspired me to live fully until the day I die.

> "On her deathbed Julia Margaret Cameron [photographer] looked out of her window at the evening sky and uttered her last word: 'Beautiful.'"
> ~ JULIA OLSON

MM: I was with each of my parents the night they died. They were in my sister's home, as I have mentioned. I got the call about my mother's imminent death while I was teaching a class. I flew from Boston to Seattle on the next plane and, since her caregivers were extremely tired, I stayed up all night with her. We didn't know if she heard or not, but I didn't want her to feel lonely so I kept talking to her in case she could hear. I knew *what* she would want to hear, so I recited Psalm 23 to her many times.

I told her that she would be held in the infinite love of the universe. Finally I realized that, knowing her, she wasn't worried about herself. So I told her that we would be all right, that we would take care of each other,

as she had always done. I told her that she could go. And she died about an hour later.

The night my father died I also stayed up with him all night. I talked and talked to him, reciting Scripture I had memorized as a child. Finally I ran out of words, and I began singing to him. I sang the old Baptist hymns I knew he loved. I had not sung them for decades, but amazingly the words, learned as a child, came back to me. He died shortly after 5:00 A.M.

Now I am the eldest in my family of origin, presumably the next to die. And because my children, resisting their childhood in the home of a Presbyterian minister, are belligerently secular, they do not know the words that I will need to hear when I am dying. Perhaps I can say them to myself. Perhaps I will not need them. Perhaps my life will gather about me and I can sail out into the universe on it. Because as Plotinus, my favorite philosopher, wrote, life does not die, but goes on to other forms.

Epilogue

Throughout our conversations we were concerned not only with the facts of our personal and professional lives, but also with the "flavor," the feelings, motivations, and attitudes that accompanied our actions and responses. Perhaps the most important element of this flavor is our refusal to feel ourselves to be at the mercy of whatever happens to us. Certainly, chance events and circumstances play a large role in anyone's life, but neither of us has been content simply to react to the complex circumstances in which we have found ourselves. We actively sought to create and shape the circumstances of our lives, even as we accepted and worked with situations we could not change. We endeavored to identify and use features of our cultures that could help and enhance our efforts to "get here from there."

A settled commitment to activity rather than passivity has not characterized the lives of most women of earlier generations. Our mothers accepted many constrictions without question. They imagined themselves helpless victims of the requirements of societies constructed by, and for the benefit of, men. They accepted that their contributions must be unpaid, and within the home. They learned to maximize their opportunities, yet without challenging the assumption that domesticity was their rightful arena.

We observed our mothers closely and decided that we did not want their lives. Yet, despite our best efforts to dismantle the assumptions about women's lives with which we began, we recognize that we would not have been successful in creating professional lives outside the home if our societies had not already been changing. If we had not been among a large number of women seeking to change themselves and their societies,

Epilogue

our efforts would simply have been stigmatized and punished. Because we were born as feminist movements were mainstreamed, our efforts to design and administer our own lives were more-or-less, and increasingly, accepted by our families, communities, and societies. We are privileged to live and work in societies that are becoming aware that women's contributions are needed and valued.

In fact, our efforts are being recognized and rewarded by the institutions and professions in which we work. Margaret gained tenure and a funded chair at a great university; her portrait has been hung in the reception room of the Harvard graduate school in which she was the first tenured woman. Recently, Hiroko was named "godmother" of the Picasso exhibition she helped realize in Helsinki. By bringing together the directors of the Picasso Museum in Paris and the Ateneum at the National Gallery of Finland the success of the exhibition was possible. During its four-month run, 350,000 people visited the exhibition, which broke all previous attendance records for art events in Finland.

As we told each other our experience in New York City, Chicago, Los Angeles, Berkeley, Tokyo, and Yamaguchi over a period of about two years, we did not conceal the fact that our accomplishments have been costly as well as rewarding. The richness of the mixture sometimes overwhelmed us, but ultimately it creates in each of us a profound gratitude. Our gratitude, in turn, creates a sense of responsibility for encouraging women to seek the lives that fit them and enable them to work together with men to address the pressing needs of their societies and the world that surrounds us.

Sources for Quotations

Aristotle. *Nichomachean Ethics*. Translated by J. A. K. Thomson. Baltimore: Penguin, 1953.
Augustine. *Epistula 104.3.11*. Translated by Wilfrid Parsons. New York: Fathers of the Church, 1953.
Augustine. *On Music*. Translated by Robert Catesby Taliaferro. New York: Cima, 1947.
Benjamin, Jessica. *The Bonds of Love*. New York: Pantheon, 1988.
Chance, Sue. *New York Times Book Review*, March 29, 1992, 11.
Clark, Anna. "Anne Lister's Construction of Lesbian Identity." In *Sexualities in History*, edited by Kim M. Phillips and Barry Reay. New York: Routledge, 2002.
Davidson, Arnold. *The Emergence of Sexuality*. Cambridge: Harvard University Press, 2001.
Dylan, Bob. "Dear Landlord." From *John Wesley Harding*. Columbia CL 2804, 1967, album.
Foucault, Michel. *The Foucault Reader*. Edited by Paul Rabinow. New York: Pantheon, 1984.
———. "On the Genealogy of Ethics." In *Michel Foucault: Beyond Structuralism and Hermeneutics*. Chicago: University of Chicago, 1983.
Garner, James R. *New York Times Book Review*, October 19, 1998, 38.
Haug, Frigga, et al. *Female Sexualization*. Translated by Erika Caner. London: Verso, 1987.
Lamott, Anne. *Bird by Bird*. New York: Anchor, 1995.
MacFarland, Dennis. *The Singing Boy*. New York: Harvey Holt, 2000.
Miles, Margaret R. *A Complex Delight: The Secularization of the Breast, 1350–1750*. Berkeley: University of California Press, 2008.
Miringoff, Marque, and Marque-Luisa Miringoff. *The Social Health of the Nation: How America is Really Doing*. New York: Oxford University Press, 1992.
Miringoff, Marque, Marque-Luisa Miringoff, and Sandra Opdycke. *The Social Report: Assessing the Progress of America by Monitoring the Well-Being of its People*. New York: Fordham Institute for Innovation in Social Policy, 2001.
Murdoch, Iris. *Metaphysics as a Guide to Morals*. New York: Routledge, 1992.
Nussbaum, Martha. *The Therapy of Desire*. Princeton: Princeton University Press, 1994.
Olsen, Victoria C. *From Life: Julia Margaret Cameron and Victorian Photography*. New York: Palgrave, Macmillan, 2003.
Phillips, Adam. *Prague*. New York: Random House, 2002.
Plotinus. *Ennead* 4.9.3. Translated by A. H. Armstrong. Loeb Classical Library. Cambridge: Harvard University Press, 1984.
Rilke, Rainer Maria. *Duino Elegies 7*. Translated by J. B. Leishman and Stephen Spender. New York: Norton, 1939.

Sources for Quotations

Robertson, Robbie. "Up on Cripple Creek." From *The Band – Greatest Hits*. Capitol 72435-24941-2-5, 2000, CD.

Rumi. *Open Secret: Versions of Rumi*. Translated by John Mogne and Coleman Barks. Putney, VT: Threshold, 1984.

Sarton, May. "Surfers." In *A Durable Fire: New Poems*. New York: Norton, 1972.

Seneca. *Letters to Lucilius* 76, 1–4. Translated by R. M. Grummere. Loeb Classical Library 76. Cambridge: Harvard University Press, 1920.

Stevenson, R. L. "Happy Thought." In *A Child's Garden of Verses*. Long Island City, NY: Star Bright, 2008.

Sultan, Faye, and Teresa Kennedy. *Over the Line*. New York: Doubleday, 1998.

Trott, Susan. *The Holy Man's Journey*. New York: Riverhead, 1997.